Johanna Basford

How to Draw
Inky Wonderlands

Create and Color Your Own Magical Adventure

PENGUIN BOOKS

PENGUIN BOOKS
An imprint of Penguin Random House LLC
penguinrandomhouse.com

ISBN 9780143133940 (paperback)

Printed in the United States of America

3 5 7 9 10 8 6 4 2

Set in Libre Baskerville
Designed by Johanna Basford and
Sabrina Bowers

This book belongs to

..

Introduction

I'm going to share a secret with you, one that the art world has been trying to keep quiet for centuries: Drawing isn't a talent, it's a skill. And it's a skill that *anyone* can master.

I am living proof of this. I was never the best at drawing in my class, but here I am! I've made a career from drawing pictures. How? Because I cracked the "drawing code":

Method + Imagination × Practice = Drawing

In this book I'll show you step-by-step how I create my illustrations. For example, I'll walk you through the method that I use to draw a stemmed flower. Once you have mastered the basic formula, you can try changing a few elements: a different shaped petal here, an extra leaf there. . . . By playing with the recipe, you can create an infinite number of variations. It's not hard, you just need to know a few tips and tricks, then practice (the more the better!).

In this book you'll find step-by-step tutorials, artwork for you to complete or color, and ideas for your own drawing projects. I've split the book into three different realms for you to explore: Garden, Ocean, and Forest.

I want *everybody* to have the confidence to pick up a pen or pencil and make their mark. You don't have to be an artist or own an easel, and you certainly don't have to create a masterpiece each time you draw. All you need to do is start. Find a pencil and doodle a little flower in the corner of this page. Go on, I know you can do it!

Let the adventure begin!

Johanna x.

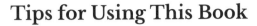

Tips for Using This Book

1. Practice on paper. You need space to draw and experiment. Find some loose sheets of paper or a sketchbook to try out the step-by-step tutorials and your new skills.

2. Pencil first, then ink. I *never* draw in pen straightaway. Every drawing begins in pencil until the sketch is almost complete, then I redraw in ink. Wait till the ink is dry, then gently erase the pencil lines. Or if you are drawing on paper thin enough to see through, place a new sheet over the top of your pencil sketch and redraw in ink on the fresh page.

For the step-by-step tutorials, draw in pencil for all the steps, until you get to the final one. For the last step, switch to a pen.

3. Test your materials. Use the test pages at the back of the book to test the color of your pens or pencils on this paper and to check for ink seeping through the page (bleeding). If it is, try pressing more lightly or switch to a different kind of pen.

4. I recommend some of the materials I use on the following page. Art materials are very personal though—what I love, you may hate! Enjoy experimenting with different items and find what works for you.

5. Have fun! Don't be too precious and give yourself permission to make mistakes. Drawing is a practice—something you will master over time.

6. There is no table of contents or index in this book. Instead, random page hopping and flipping from project to project is encouraged!

7. Discover More! Check out the free hidden resources I have created to accompany this book. There are lists of my favorite art materials, exclusive downloads, bonus tutorials, and lots more!

www.johannabasford.com/howtodraw

Tip: *To evenly position petals around the center of a flower, imagine the middle of the flower as a clockface. Draw petals at twelve, three, six, and nine o'clock—splitting your circle into quarters. Now draw a petal in each gap. You can vary the size of the petals and also how many you draw in each gap to create a lot of variations.*

Materials

Here are some tips on the materials and tools I like to draw with.
 Part of the fun is finding the things you love to create with, so use these notes as a guide and have fun exploring the world of art supplies!

1. Paper

For practice, regular white office paper is good, or you can use a sketchbook. I'd suggest something white or ivory with a smooth texture. I like to draw on *layout paper*, as my pen and pencils glide over the smooth surface. It's also thin enough that I can lay one sheet on top of another and trace the drawing below.

2. Pencils

I use a *mechanical pencil*. They look like pens but with graphite instead of ink inside them. I like a *0.5 size HB or B lead*—they are soft enough to draw with, without being too smudgy.
 When tracing, I use a regular pencil with a very soft lead like a *3B* to scribble on the back of the tracing paper. This stops the tracing paper from ripping or from causing any scratchy indentation to the page below.

3. Pens

After I have sketched my drawing, I redraw it in ink using a *0.2 size fineliner pen*. The nibs are a good size for drawing small details and the fiber tip nibs are easy to control.

4. Sharpener

Mechanical pencils don't need to be sharpened, but you'll need to sharpen your coloring pencils. For mass sharpening sessions I like a *rotary sharpener*—it bolts to my desk and I turn the handle to create perfect points without any blisters! I keep a cheap and cheerful little sharpener in my pencil case for everyday use.

5. Eraser

To avoid smudges, use a clean, white *plastic eraser*. Remove any black bits on it by rubbing on a blank sheet of paper or your desk before use.

6. Coloring

Coloring pencils are the easiest and most versatile option. You can layer and blend the colors to create a multitude of different effects.

Pens are a little trickier. They create bold pops of color but can bleed, so test them on the pages at the back of the book before use. *Glitter, metallic, and scented gel pens* are all fun to try!

7. Compass

Using a *compass* is a cheap and cheerful way to draw perfect circles of any size.

8. Tracing Paper

If you don't have *tracing paper*, use *baking parchment*. This very thin paper allows you to layer it over a drawing and trace it, so you can then copy the artwork to create a symmetrical motif.

9. Graph Paper

Helpful for creating borders or squares. You can either draw directly on the *graph paper* or place a thin sheet of white paper on top so you can see the squared paper below to guide you.

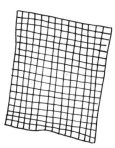

Blooms

Most flowers begin as a simple dot or circle. Each of these blooms can be drawn in five simple steps. Draw steps one through four in pencil, then go over your pencil lines in ink, adding detail and embellishments. Finally, erase the pencil lines. Practice your flowers on a sheet of paper.

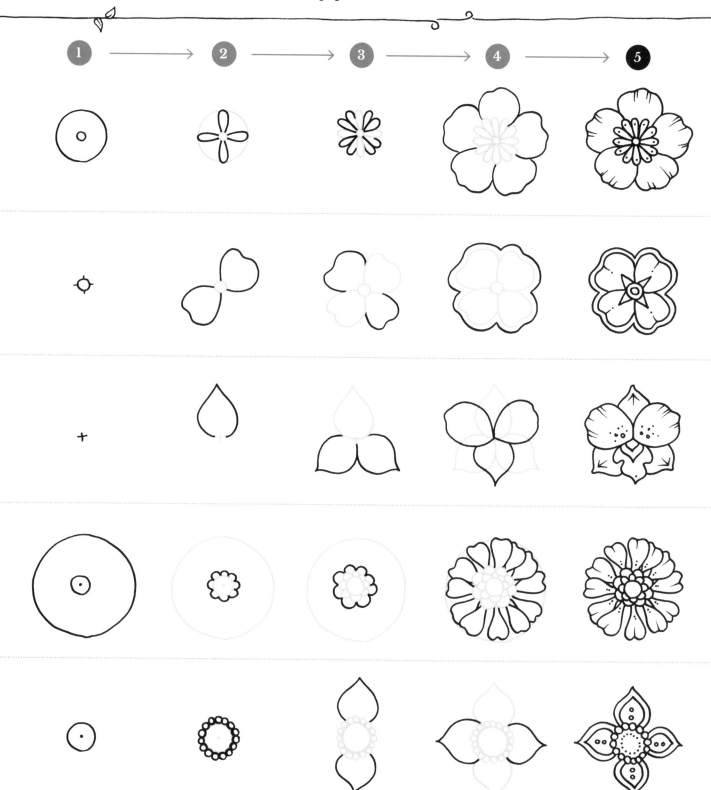

Tip: *Outline the spaces between the flowers to create a stained-glass effect.*

Create your own unique blooms by combining bits from different flowers. Here are some ideas to get you started. Add inky details to these flowers and create a page to color.

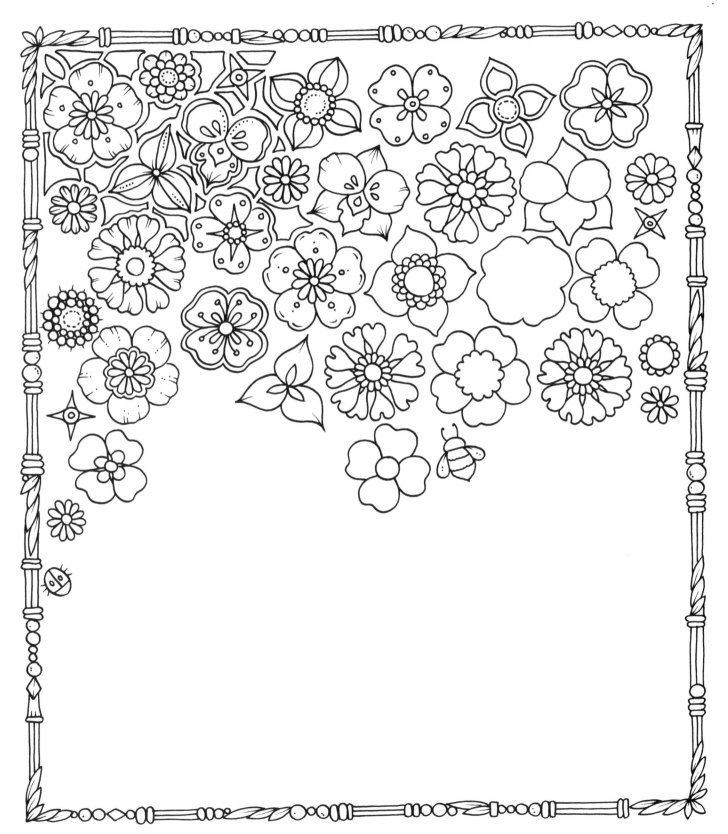

Leaves

Foliage is just as important as flowers—ask any florist! I use variations of these five basic leaves in most of my illustrations. Always begin with the stem, then draw the outline of the leaf shape before adding details like veins or patterns.

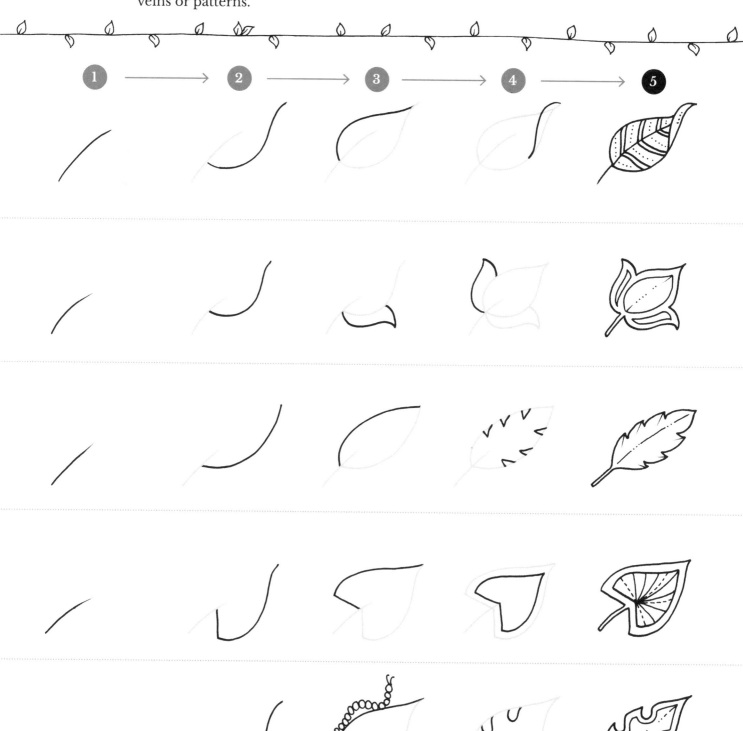

Embellish the leaves on these garlands
with inky details or a splash of color.

Idea: *Try adding your name or an inspiring quote
inside each of the garlands.*

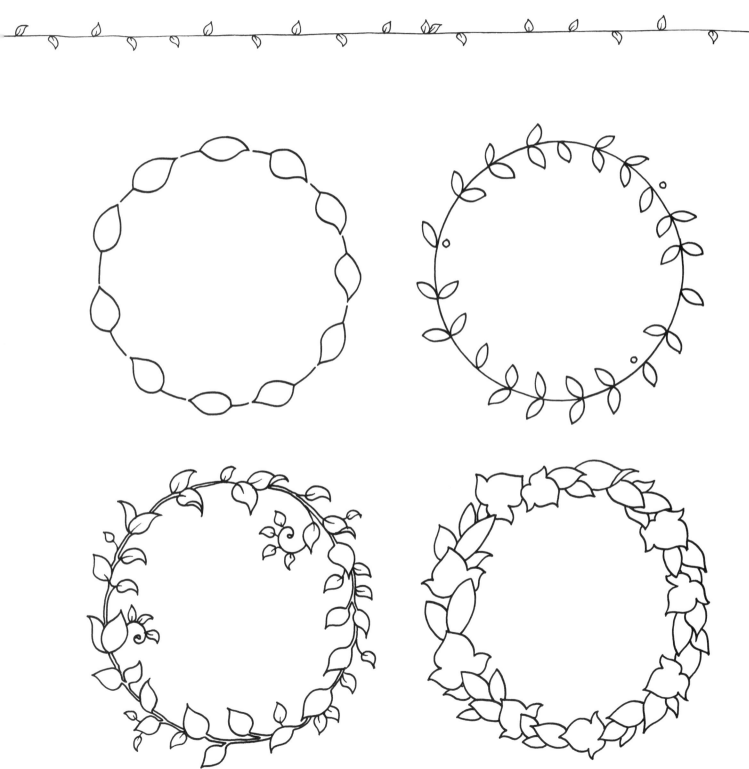

Botanical Borders

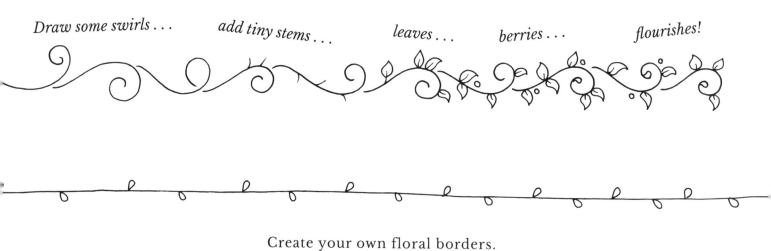

Draw some swirls . . . *add tiny stems . . .* *leaves . . .* *berries . . .* *flourishes!*

Create your own floral borders.

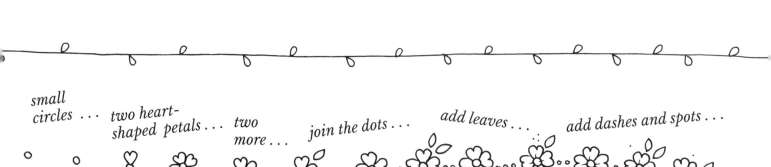

small circles . . . *two heart-shaped petals . . .* *two more . . .* *join the dots . . .* *add leaves . . .* *add dashes and spots . . .*

small
circles . . .

add
two
petals . . .

two
more . . .

leaves . . .

a wobbly
stem . . .

the other side
of the stem . . .

more leaves . . .

Tip: *Rotate the petal positions so your flowers aren't all exactly the same.*

circles . . .

heart-shaped
petals . . .

stem . . .

leaves . . .

more
leaves . . .

dashes
and details . . .

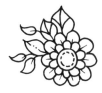

Posies

These three simple little flower and leaf posies are easy to draw and oh so pretty—perfect for embellishing a handwritten letter or doodling on a notebook. Follow the steps below, or mix things up and create your own unique combinations of flowers and leaves.

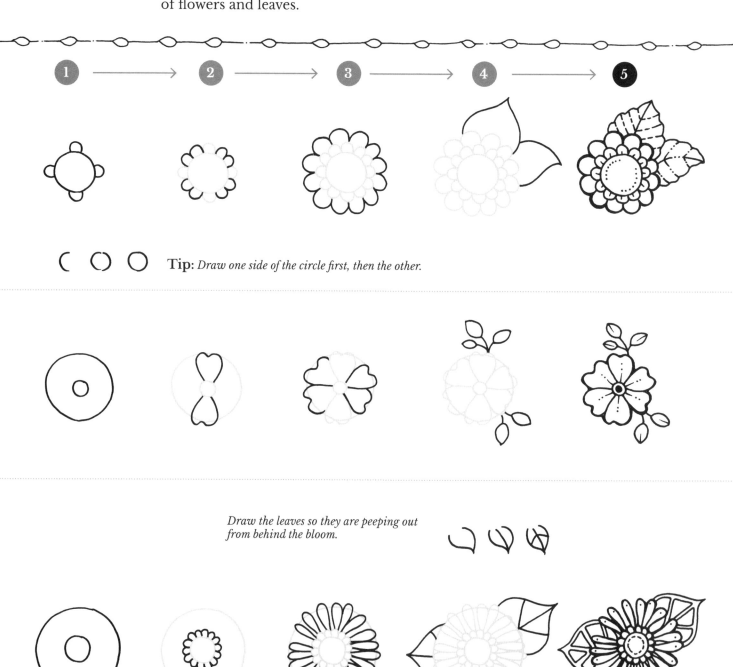

Tip: *Draw one side of the circle first, then the other.*

Draw the leaves so they are peeping out from behind the bloom.

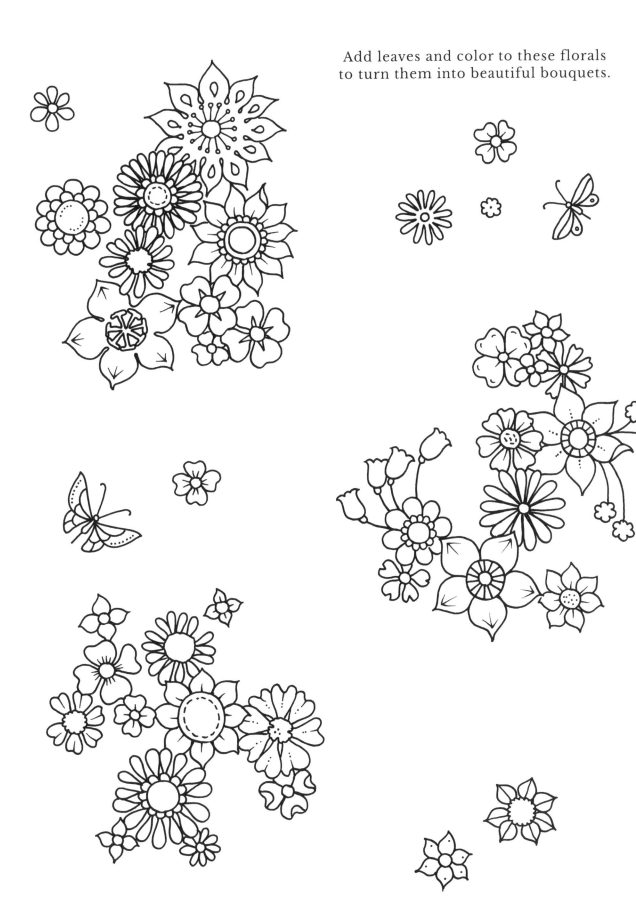

Add leaves and color to these florals
to turn them into beautiful bouquets.

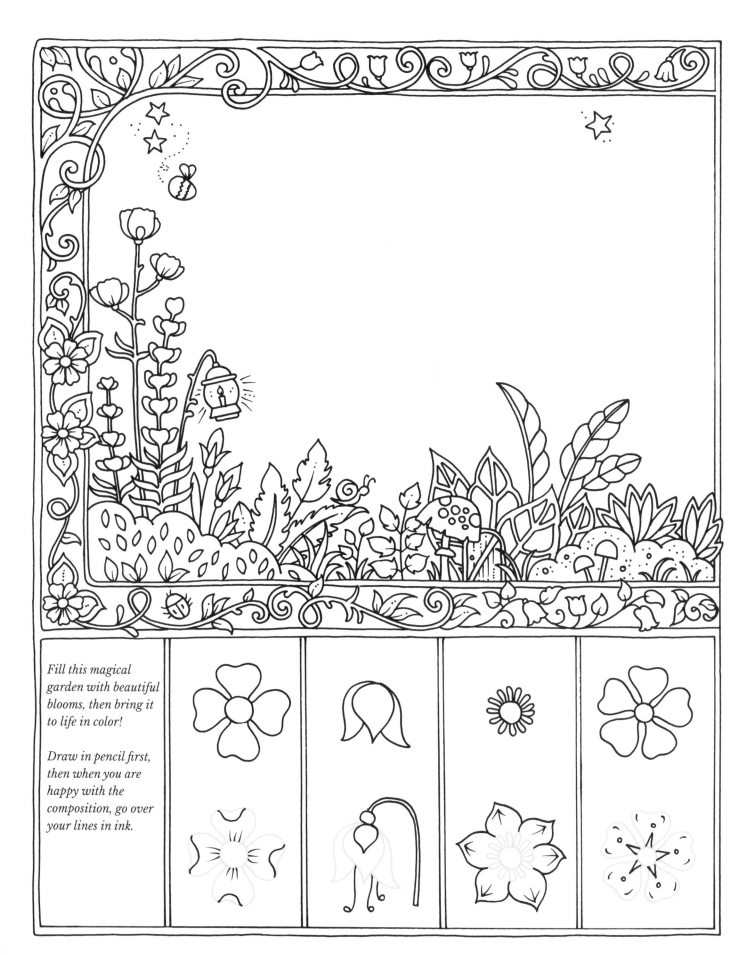

Fill this magical garden with beautiful blooms, then bring it to life in color!

Draw in pencil first, then when you are happy with the composition, go over your lines in ink.

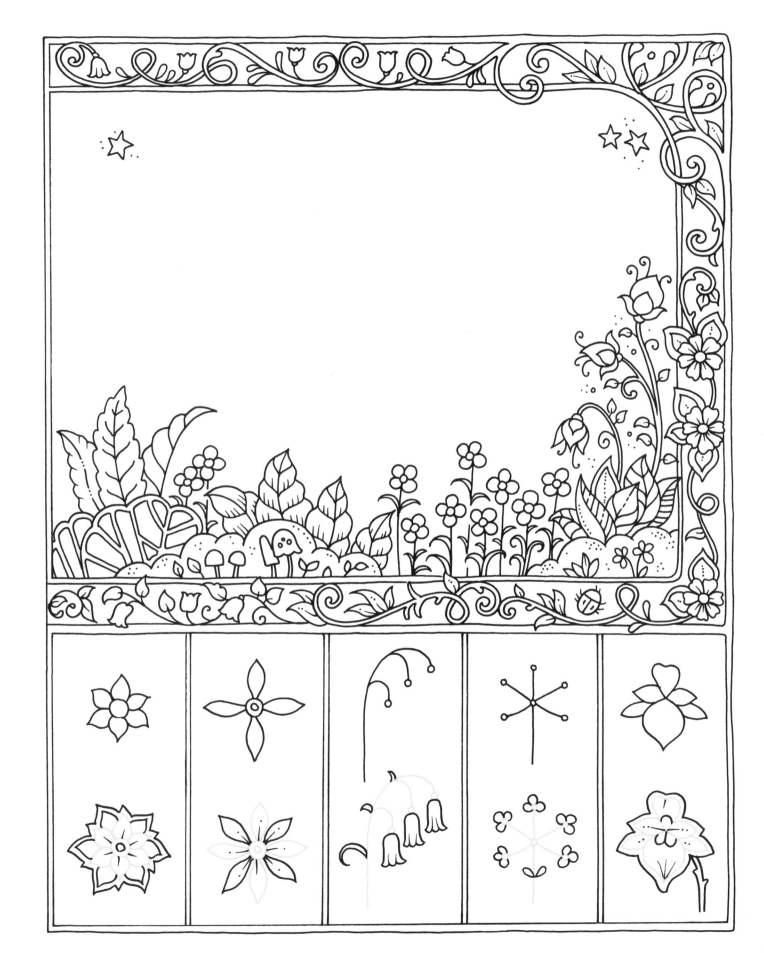

Bouquet

The trick here is to overlap the blooms and have flowers peeping out behind petals, so you create a feeling of depth. Drawing in pencil means you can layer flowers and leaves over each other, before redrawing in ink.

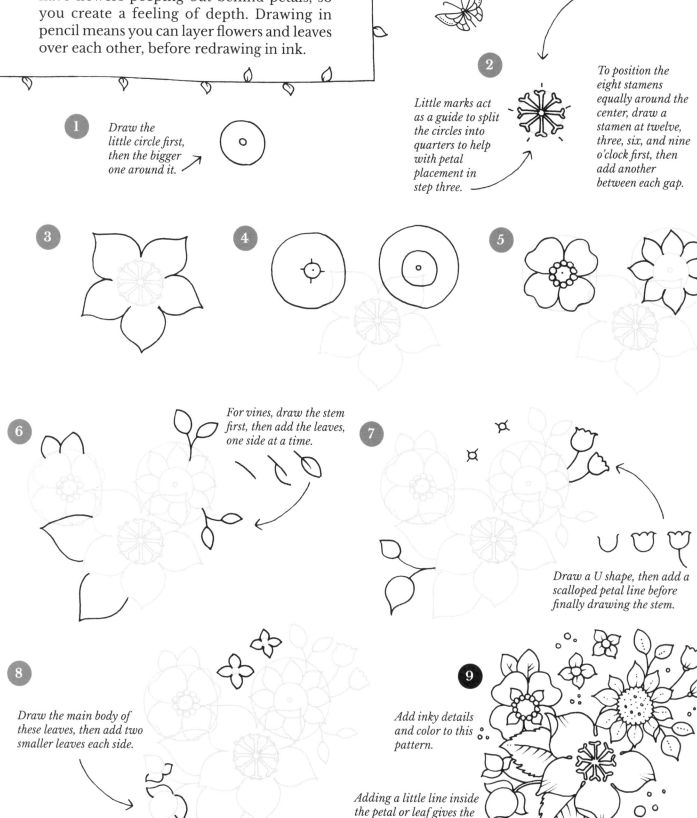

These little arms coming from the center of the flower are called the stamens.

1 *Draw the little circle first, then the bigger one around it.*

2 *Little marks act as a guide to split the circles into quarters to help with petal placement in step three.*

To position the eight stamens equally around the center, draw a stamen at twelve, three, six, and nine o'clock first, then add another between each gap.

3

4

5

6 *For vines, draw the stem first, then add the leaves, one side at a time.*

7 *Draw a U shape, then add a scalloped petal line before finally drawing the stem.*

8 *Draw the main body of these leaves, then add two smaller leaves each side.*

9 *Add inky details and color to this pattern.*

Adding a little line inside the petal or leaf gives the impression of a fold.

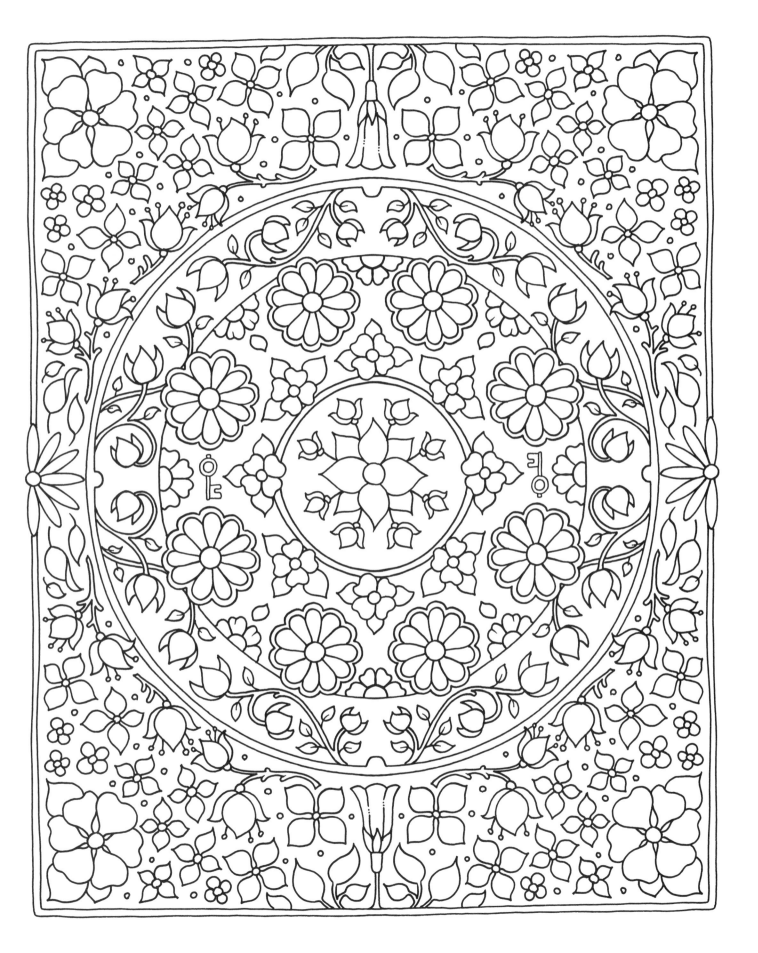

Inky Insects

I love hiding little surprises like ladybugs and dragonflies in my drawings.
Practice these inky insects on some paper, then hide them in your pictures.

① → **②** → **③** → **④** → **5**

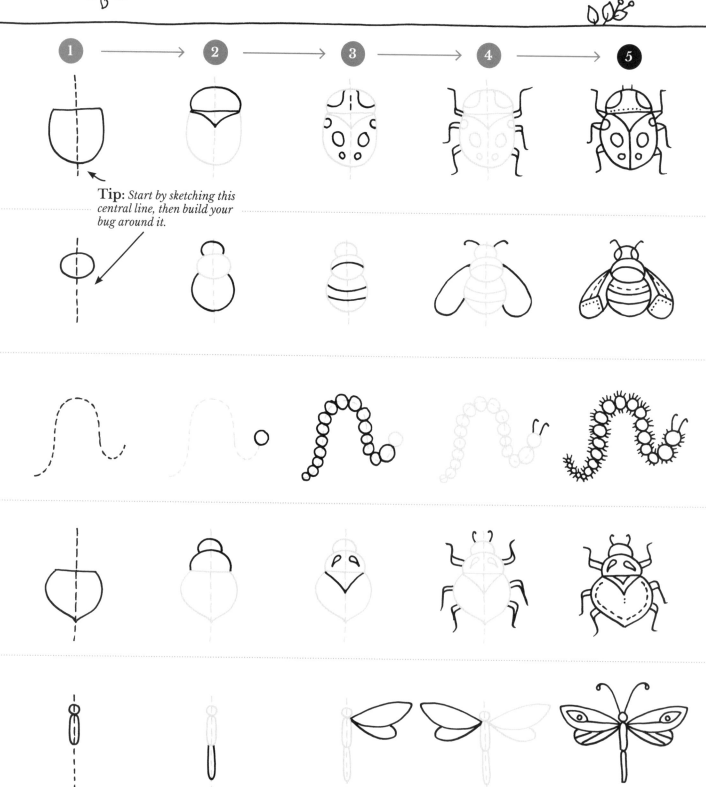

Tip: *Start by sketching this central line, then build your bug around it.*

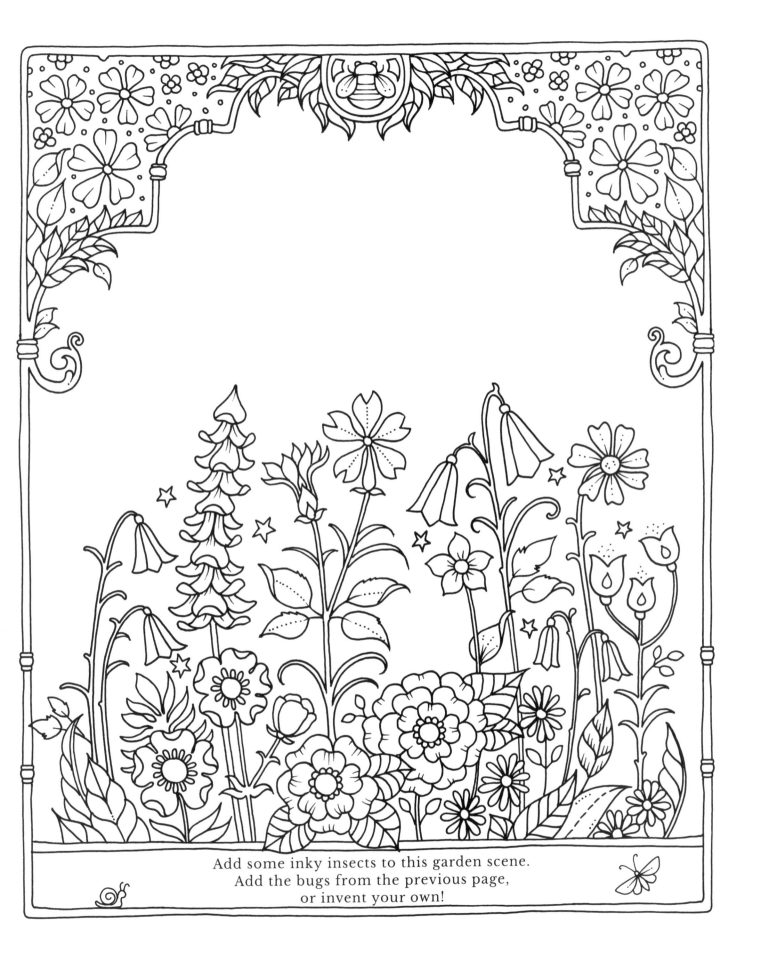

Add some inky insects to this garden scene.
Add the bugs from the previous page,
or invent your own!

Flowers

Each of these simple stemmed flowers follow the same basic pattern: stem, bud, petals, leaves. Use this formula to create your own inky blooms.

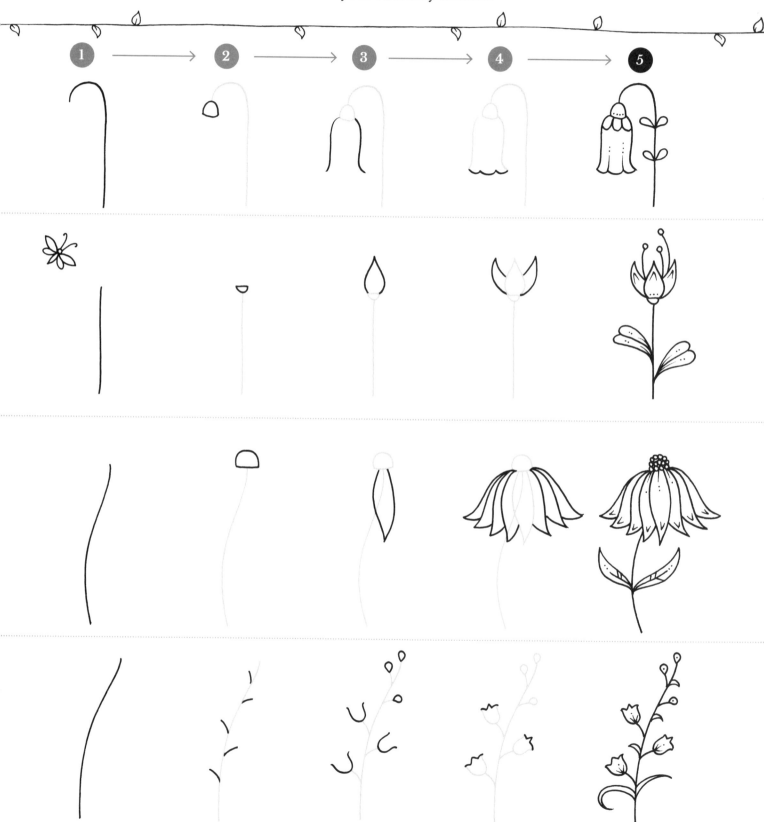

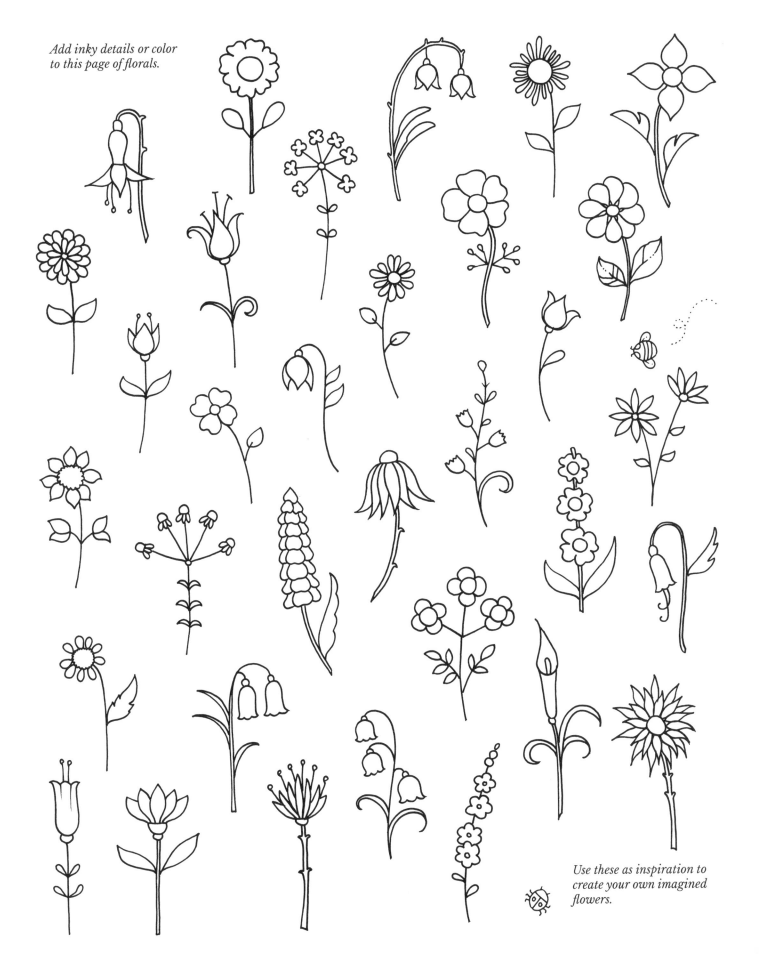

Add inky details or color to this page of florals.

Use these as inspiration to create your own imagined flowers.

Super Skill: Symmetry

Creating a symmetrical motif looks super clever, but it is actually really easy—the secret trick is tracing paper. For this example, we'll draw a swirly heart.

1. Use a pencil to mark the center line on a regular piece of paper; this will be your line of symmetry.

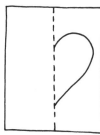

2. Again using your pencil, draw half a heart.

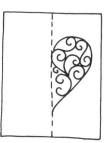

3. Now fill the heart with swirls.

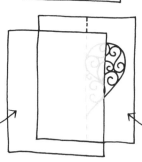

tracing paper → ← *paper*

4. Lay a sheet of tracing paper over the pencil drawing. You will faintly see the pencil drawing below.

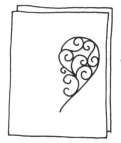

5. Still using the pencil, trace the half heart onto your tracing paper.

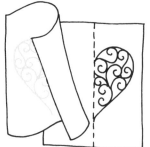

6. Now flip your tracing paper over, so the pencil lines you just traced are now *facedown* on the paper below.

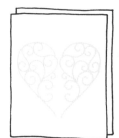

7. Line up the tracing paper so the two halves of the heart meet.

8. Using a pencil, scribble on the reverse of the tracing paper, over the *back* of the heart you just traced. This will transfer the tracing to the paper below.

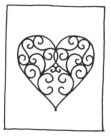

9. Remove the tracing paper and ta-da! You will have a fully drawn pencil heart on the paper below!

Tip: *Hide the connection between the two halves by overlapping some leaves or adding additional small elements.*

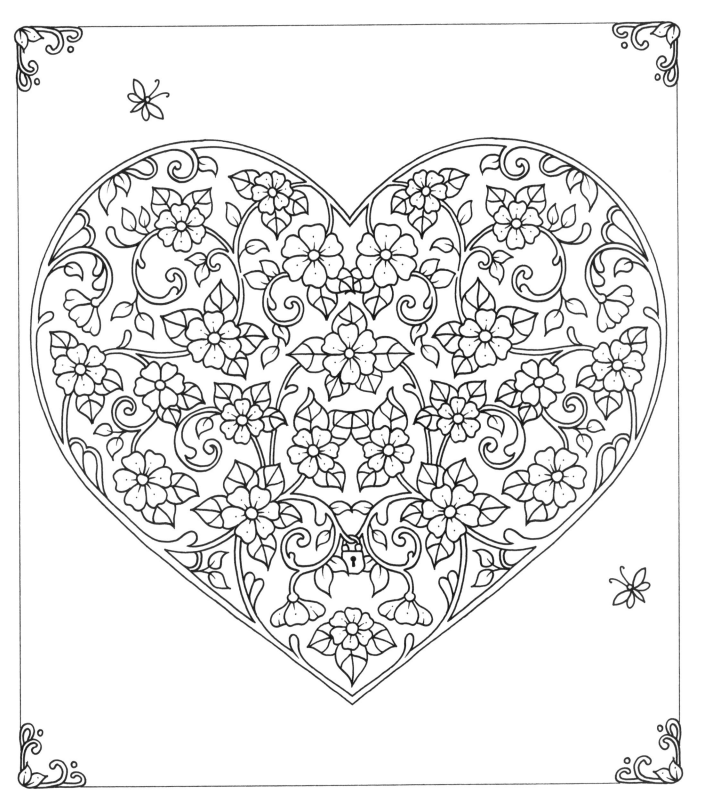

I used the method from the previous page to create this botanical heart,
except instead of tracing paper to flip the design, I used the computer.
Either way works perfectly—but you definitely do not
need a computer to draw symmetrical designs.

Butterflies

Butterflies are one of my favorite things to draw and are so easy once you know a few tricks. Use the symmetry technique to make wings that are mirror images of each other, and don't forget to go wild with the patterns and markings!

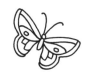

1

Start with a simple vertical line. This will be your line of symmetry. Next, draw a little circle for the head.

2

Add an elongated teardrop shape for the body, then a skinny cigar shape for the "tail."

3

Now the wings. Draw a large upper wing.

4

Follow with a smaller lower wing.

5

Now section the wings into panels; this makes adding smaller details easier.

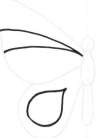

6

Add details to the wing sections and antennae.

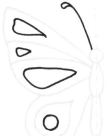

7

Now use your tracing paper and the symmetry technique to flip the drawing, creating one whole butterfly.

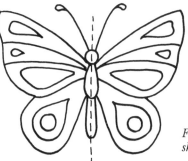

Finally, redraw in ink, erase the pencil sketch, and add inky details or color.

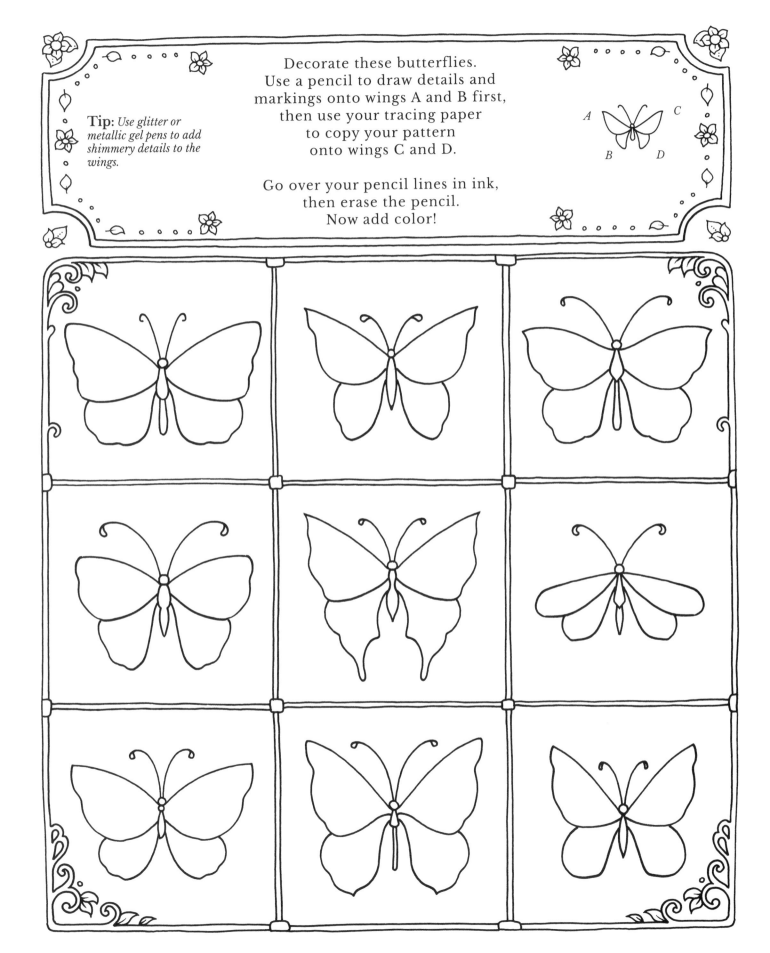

Decorate these butterflies.
Use a pencil to draw details and
markings onto wings A and B first,
then use your tracing paper
to copy your pattern
onto wings C and D.

Go over your pencil lines in ink,
then erase the pencil.
Now add color!

Tip: *Use glitter or metallic gel pens to add shimmery details to the wings.*

A C
B D

Spherical Motif

I adore these delicate spheres of flowers—I've been drawing them since art school! Large motifs can be framed for display in your home while smaller ones are perfect for items like greeting cards and wedding invites. Start with a circle outline, then fill it with blossoms and foliage. Try this technique using a square, star, or even a heart shape. And you don't need to fill the circle with flowers; you could draw candy, fish, or even birds. The basic principle is to start with the outline, then fill with the details.

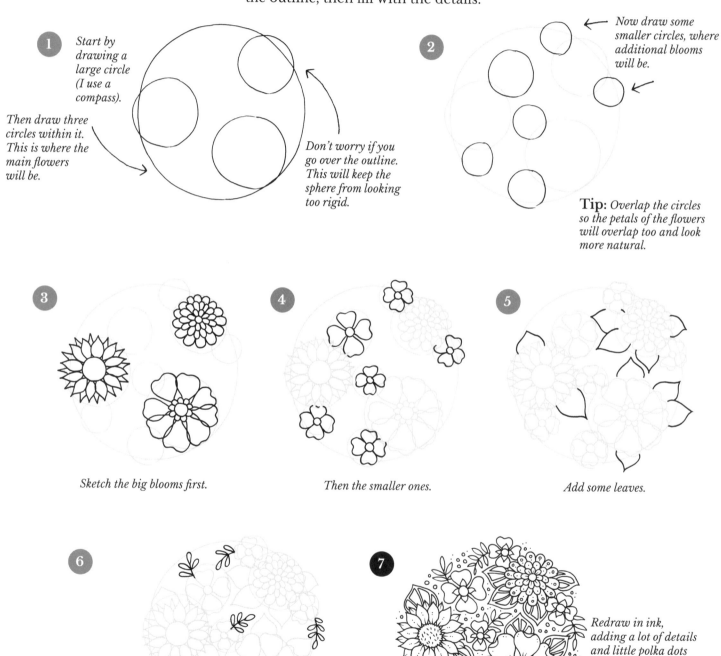

1 *Start by drawing a large circle (I use a compass).*

Then draw three circles within it. This is where the main flowers will be.

Don't worry if you go over the outline. This will keep the sphere from looking too rigid.

2 *Now draw some smaller circles, where additional blooms will be.*

Tip: *Overlap the circles so the petals of the flowers will overlap too and look more natural.*

3 *Sketch the big blooms first.*

4 *Then the smaller ones.*

5 *Add some leaves.*

6 *Fill gaps with little ferns.*

7 *Redraw in ink, adding a lot of details and little polka dots to fill any areas of blank space.*

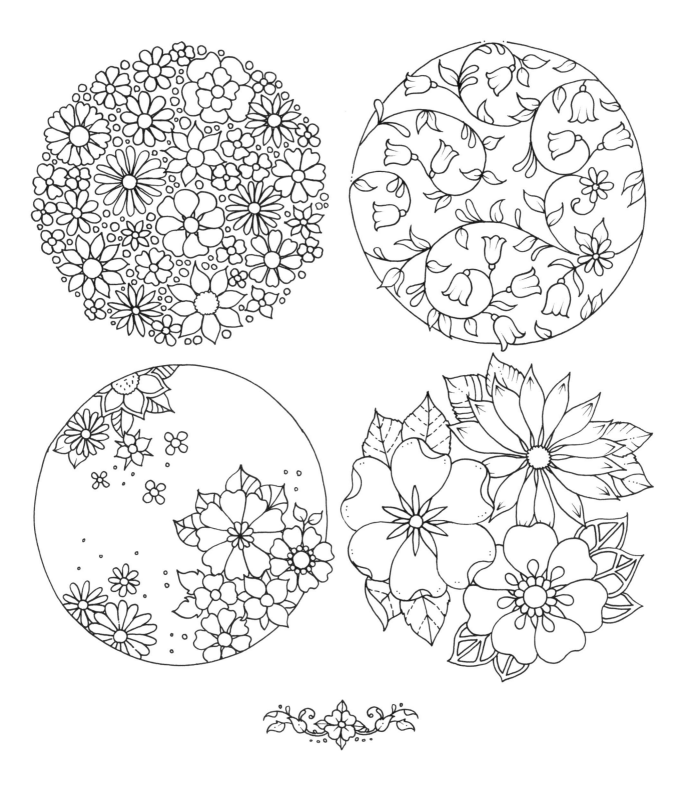

These motifs are all variations of the idea on the previous page.
Much of my drawing style is about making small changes to a basic formula—
for example, differing the size of the flowers, inking the outline of the shape,
leaving plenty of white space, or filling every gap with polka dots.

Floral Garlands

Simple yet beautiful, these rings of flowers and foliage never fail to delight. The basic principle is similar to drawing a sphere: outline, blooms, leaves, then filler foliage.

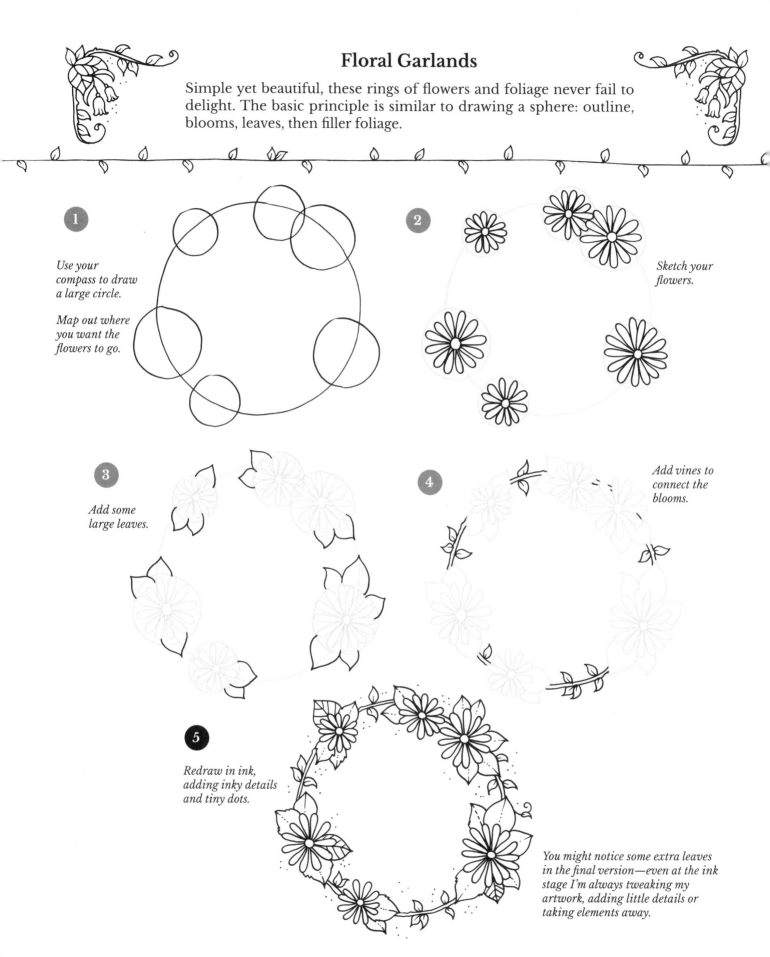

1

Use your compass to draw a large circle.

Map out where you want the flowers to go.

2

Sketch your flowers.

3

Add some large leaves.

4

Add vines to connect the blooms.

5

Redraw in ink, adding inky details and tiny dots.

You might notice some extra leaves in the final version—even at the ink stage I'm always tweaking my artwork, adding little details or taking elements away.

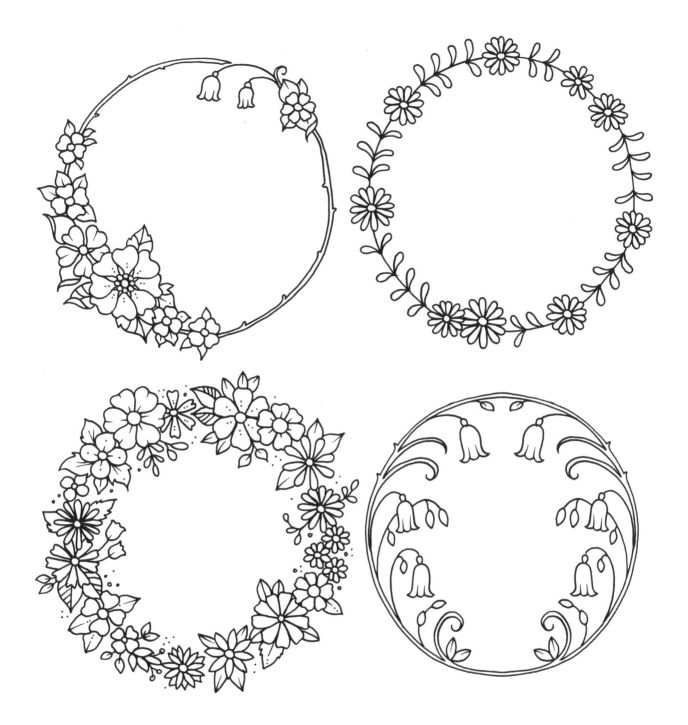

Some simple tweaks to the basic garland formula allow you to create many different variations. Here are some ideas:

1. *Contemporary:* Leave some of the ring bare.
2. *Stylized:* Draw a simple flower and leaf combination.
3. *Full:* Use a lot of varied, densely packed blooms.
4. *Symmetrical:* Create half the motif, then flip and join.

Symmetrical Crest

You can create these with or without the space in the middle. I use this style of illustration for the "This book belongs to . . ." page in my books. Depending on what text you add you could use this style of artwork for personal logos, invitations, menus, and much more!

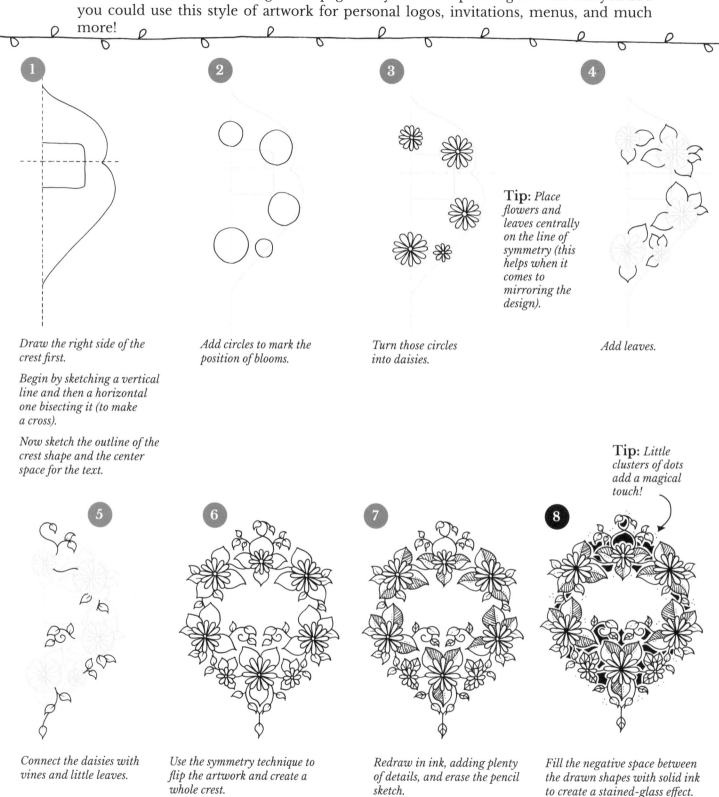

Draw the right side of the crest first.

Begin by sketching a vertical line and then a horizontal one bisecting it (to make a cross).

Now sketch the outline of the crest shape and the center space for the text.

Add circles to mark the position of blooms.

Turn those circles into daisies.

Tip: *Place flowers and leaves centrally on the line of symmetry (this helps when it comes to mirroring the design).*

Add leaves.

Tip: *Little clusters of dots add a magical touch!*

Connect the daisies with vines and little leaves.

Use the symmetry technique to flip the artwork and create a whole crest.

Sometimes you need to tweak little bits that are on the join line.

Redraw in ink, adding plenty of details, and erase the pencil sketch.

Fill the negative space between the drawn shapes with solid ink to create a stained-glass effect.

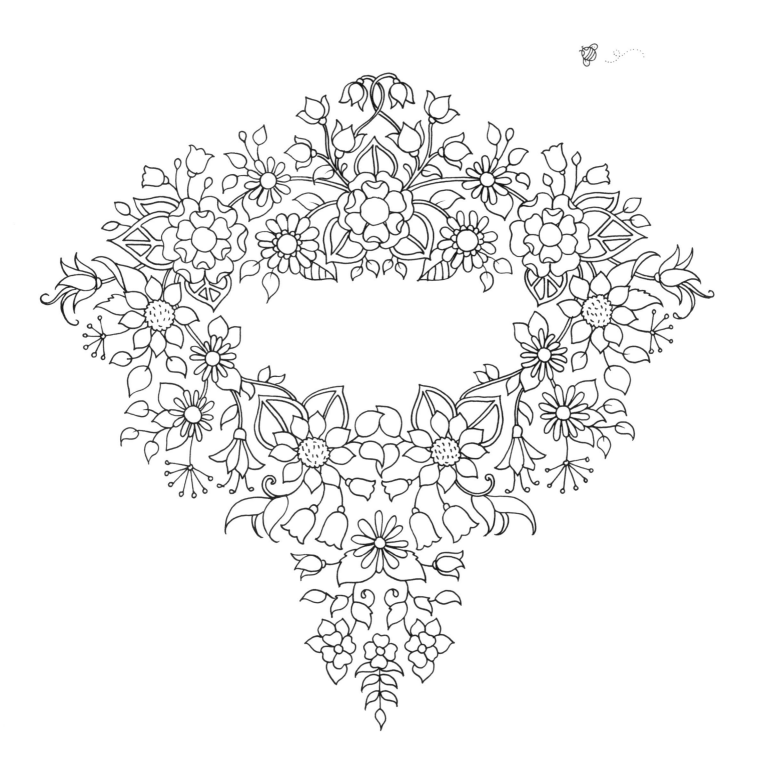

This crest needs inky details and color to bring it to life.
What will you write inside it?
You could add some butterflies or buzzy bees
in the space around the artwork.

Patterns

Computers have fancy ways of designing an exact repeat pattern, but you can create them by hand too.

Add inky details and color to this patterned page. →

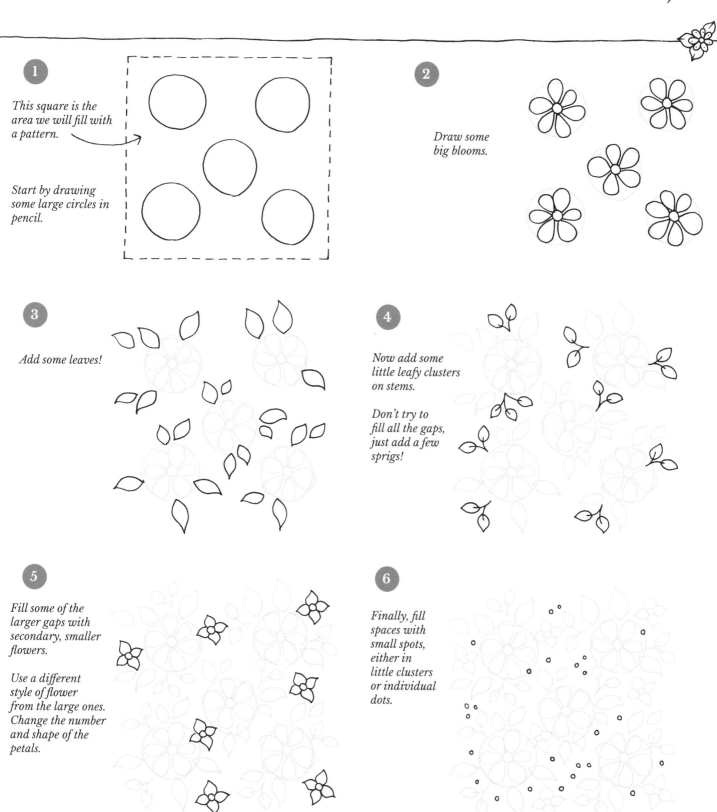

1

This square is the area we will fill with a pattern.

Start by drawing some large circles in pencil.

2

Draw some big blooms.

3

Add some leaves!

4

Now add some little leafy clusters on stems.

Don't try to fill all the gaps, just add a few sprigs!

5

Fill some of the larger gaps with secondary, smaller flowers.

Use a different style of flower from the large ones. Change the number and shape of the petals.

6

Finally, fill spaces with small spots, either in little clusters or individual dots.

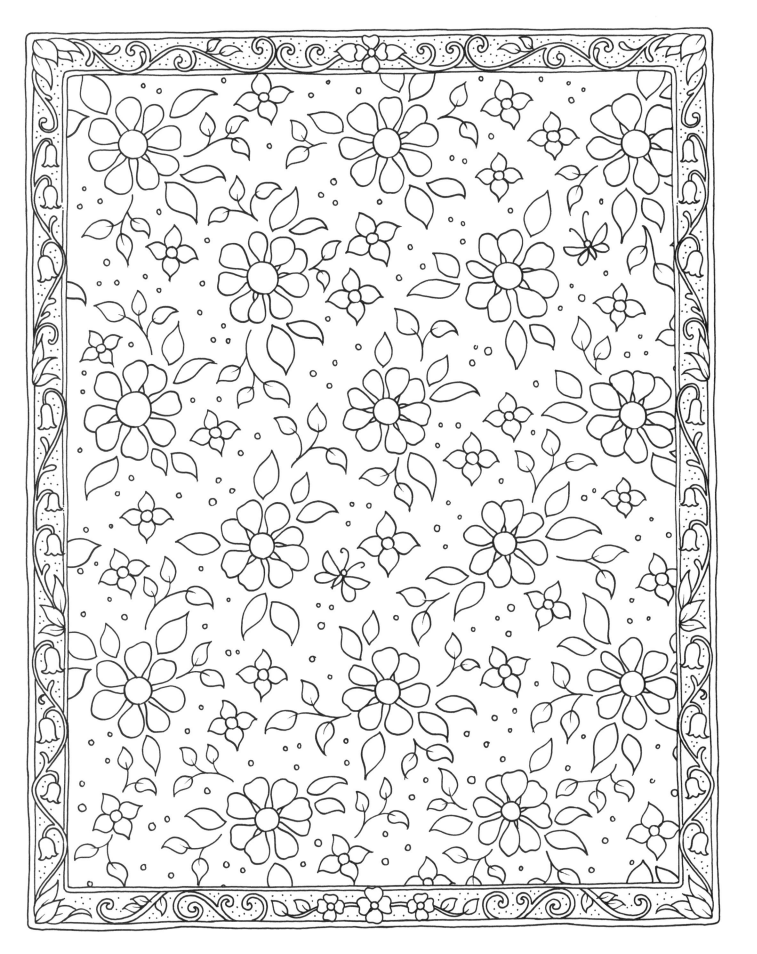

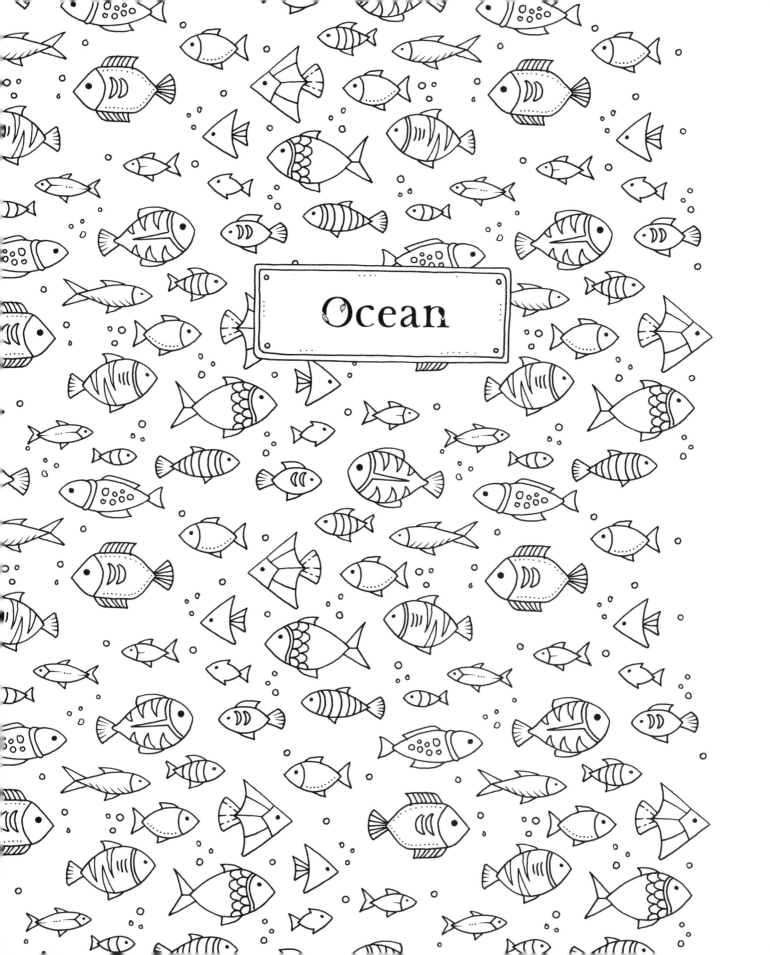

Ocean

Go Fish!

When drawing fish I always use my fishy formula: body, tail, fins, then details. Mix and match different shapes and patterns to create an infinite variety of fishes—grab your pencil and dive in!

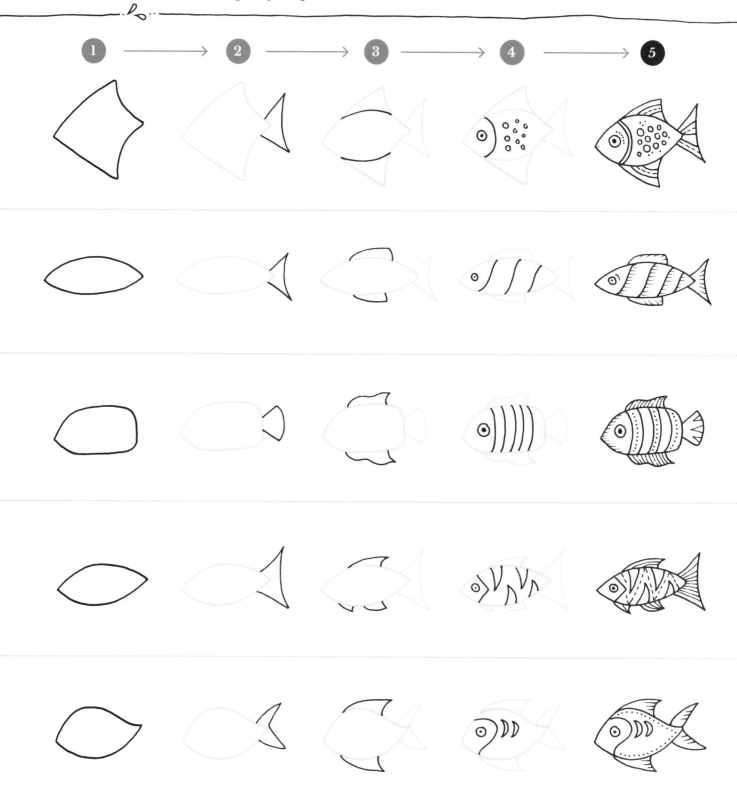

Fill this seascape with lots of fish,
then add a splash of color!

Ship Ahoy!

The trick to my style of drawing is to master the basic formula, then have fun tweaking the recipe to create an infinite number of variations. This works with flowers, leaves, and even boats!

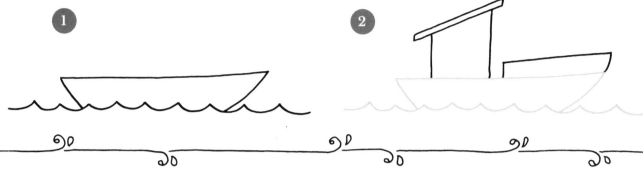

Draw the base of the boat first (the hull), then add things like a wheelhouse, safety rails, masts, flags, and chimneys.

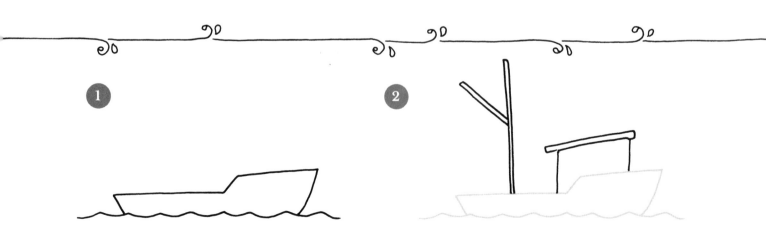

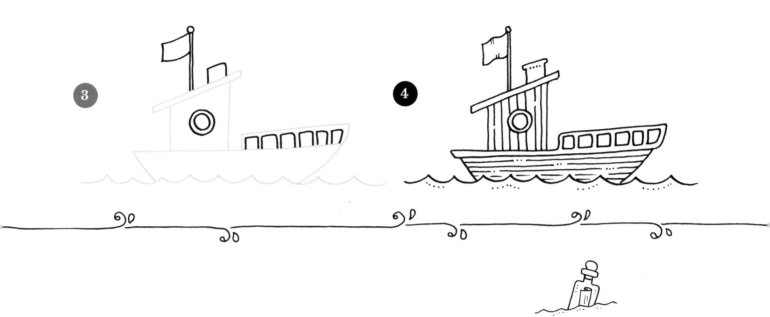

Fill this stretch of ocean with fishing boats of all shapes and sizes.

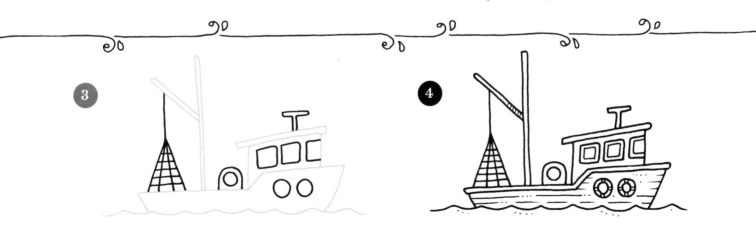

*Use these ideas as inspiration and
fill the fish outlines with patterns of your own.
Bring them to life with a splash of color.*

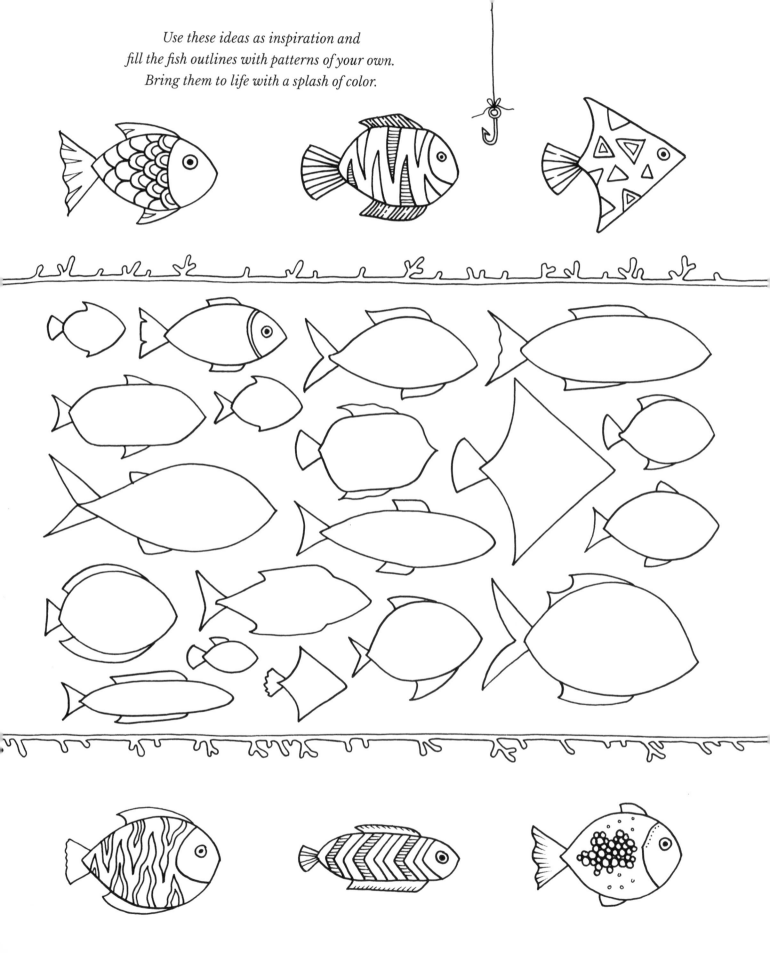

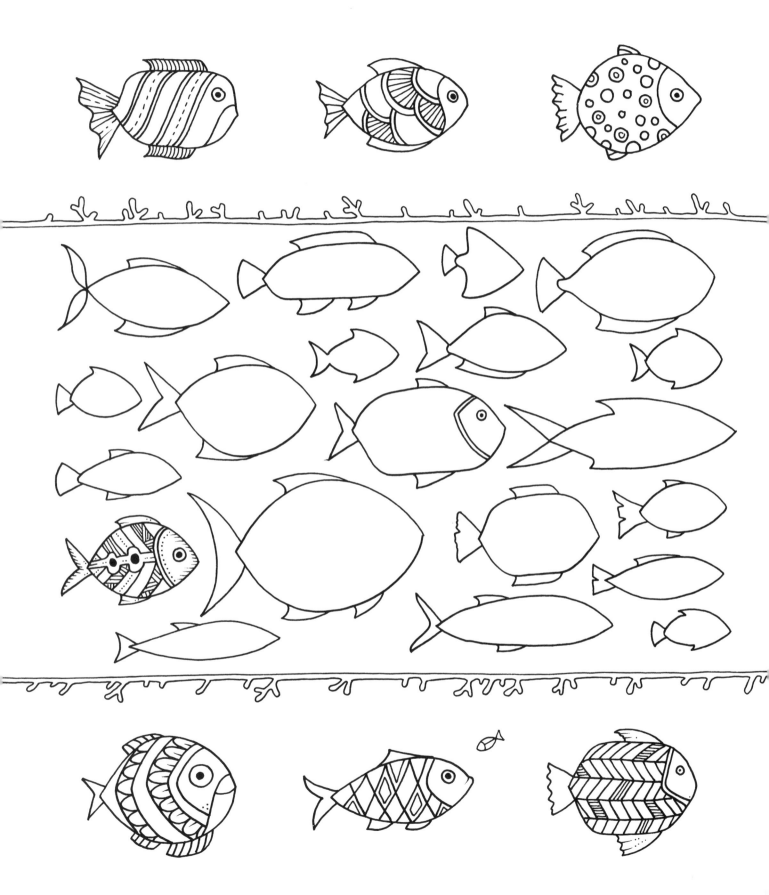

Seaweed Tangle

Follow this step-by-step to create a tangle of seaweeds and sea urchins. Experiment by adding bits of sunken treasure, tiny fish, or the odd inky jellyfish to your creations!

Add inky details to these outlines and fill the empty space with your own seaweed tangles! ⟶

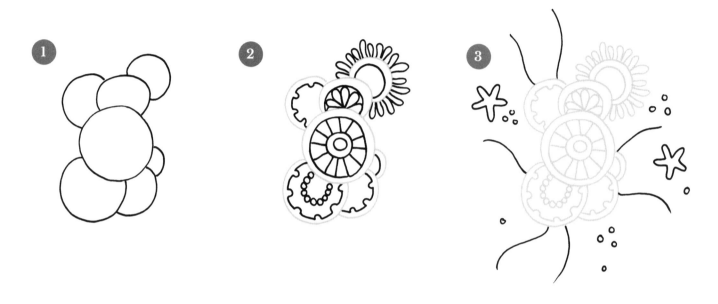

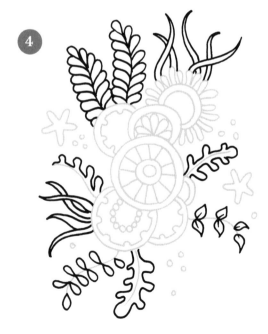

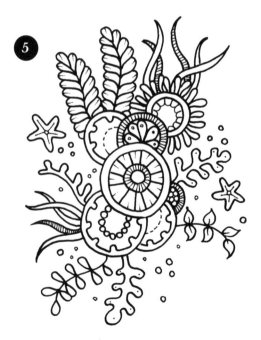

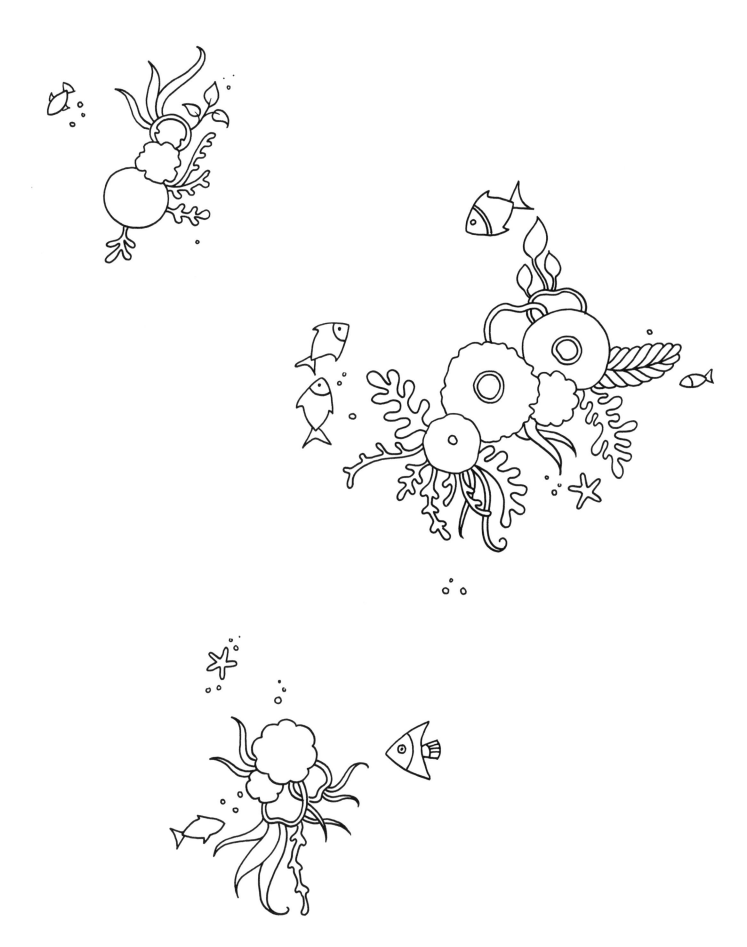

Treasure

No pirate ship would be complete without some treasure. These little trinkets come in handy for all sorts of illustrations from magpie nests to castle dungeons!

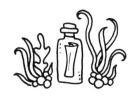

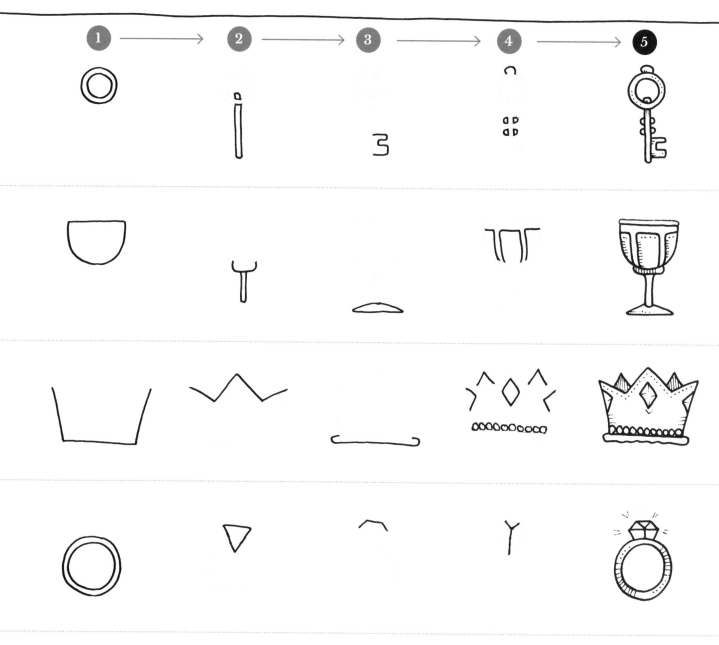

Fill this page with treasures and trinkets.

*Try experimenting with glitter gel pens
to add a little sparkle to your creations!*

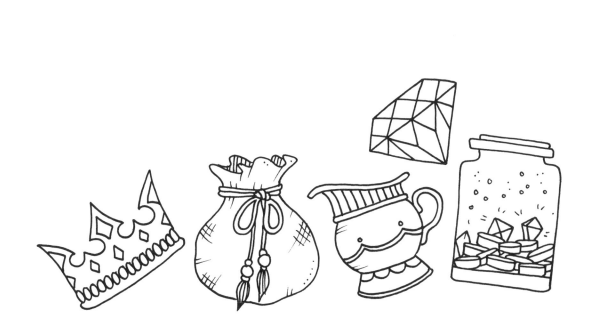

Flotsam and Jetsam

These little drawings are perfect for adding a touch of nautical charm to invitations, greetings cards, or treasure maps.

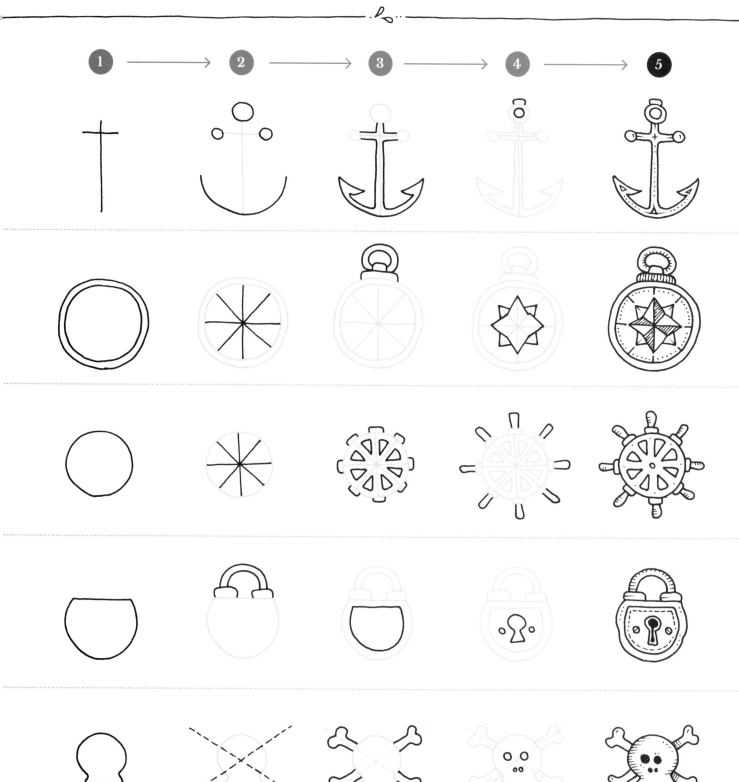

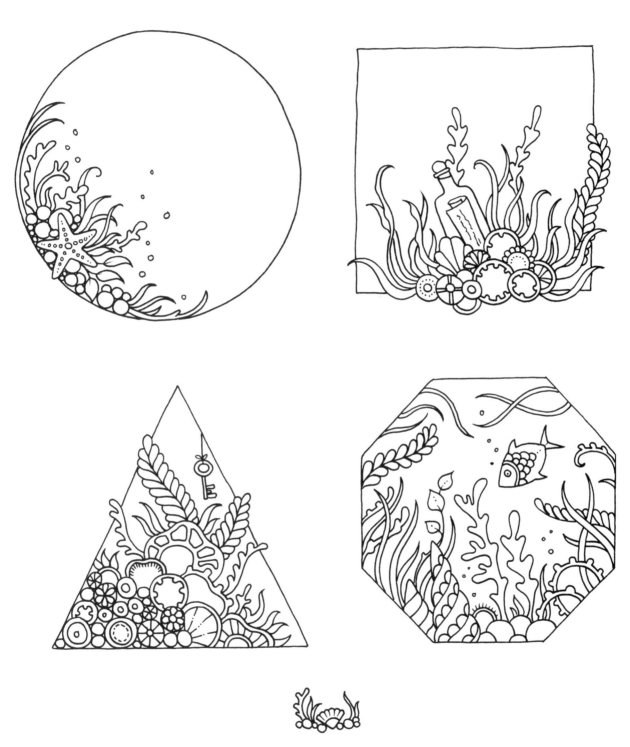

Create your own ocean-inspired geometric shapes.
Start by drawing your shape, then fill it with seaweeds, corals,
and some deep-sea surprises. You can keep the elements constrained
within the shape or let them "grow" and overlap the outline.

Crabs

With lots of little legs and a big body for patterns, crabs are a lovely addition to a tide pool drawing. I also use this technique for drawing spiders—it's an easy way of creating a balanced beastie!

This ocean crest is another example of where symmetry can be useful.

Add details to the simple outlines and fill those fish with color!

———————→

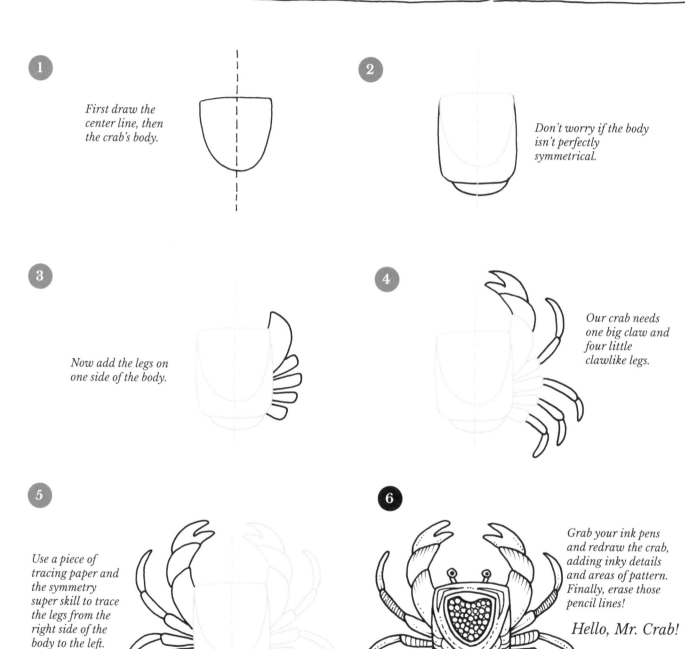

1 *First draw the center line, then the crab's body.*

2 *Don't worry if the body isn't perfectly symmetrical.*

3 *Now add the legs on one side of the body.*

4 *Our crab needs one big claw and four little clawlike legs.*

5 *Use a piece of tracing paper and the symmetry super skill to trace the legs from the right side of the body to the left.*

6 *Grab your ink pens and redraw the crab, adding inky details and areas of pattern. Finally, erase those pencil lines!*

Hello, Mr. Crab!

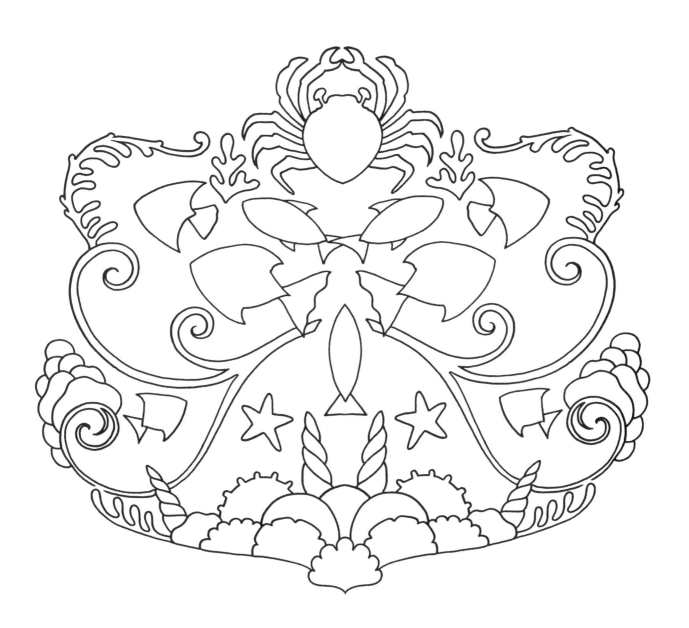

Ocean Pattern

I call this type of pattern a *mega-doodle*! Start small, then let your barnacle-inspired pattern grow to fill any space. I love to create little puddles of intricate ink on the backs of envelopes, corners of notebooks, and on train tickets.

Fill this frame with your own ocean-inspired mega-doodle!

 1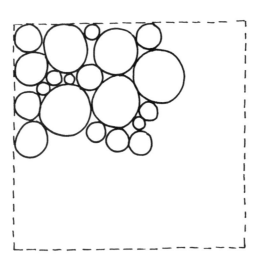

Use your pencil to draw a variety of different size circles within the space you want to fill.

2

I like to draw a few big circles, then use smaller ones to fill the gaps.

3

Now fill the circles with different doodles. I try to imagine barnacles, sea urchins, pebbles, and shells.

4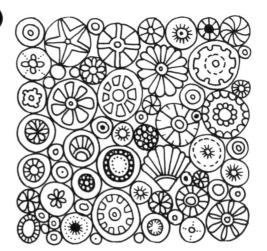

Finally, grab a pen and go over your sketched lines in ink, then erase the pencil—all your mega-doodle needs now is a splash of color.

Seashells

All these shells begin as simple shapes, but after just a few steps and with some inky embellishments, they become pretty seaside trinkets!

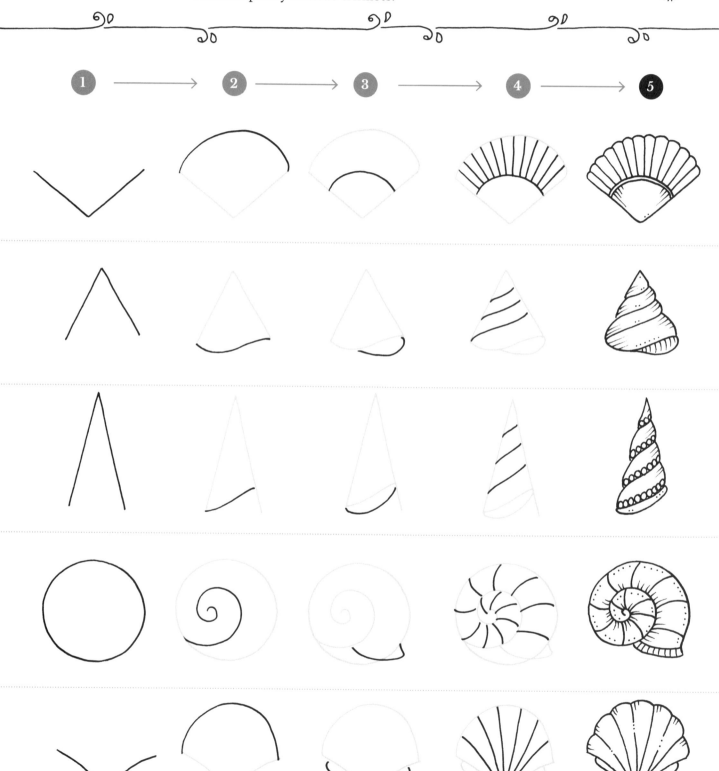

These flourishes use the symmetry technique. I sketch one side, then use tracing paper (or the computer!) to mirror the artwork to the opposite side. A simple swirl with a few extra details, maybe a shell or a leaf, can become the perfect finishing touch to a journal entry, a letter, or a writing project.

Seaweed

Seaweeds are the flowers of the ocean and are as easy to master as any garden vine. Just start with a stem, then build it up from there, creating as many variations of the basic principle as your imagination will allow.

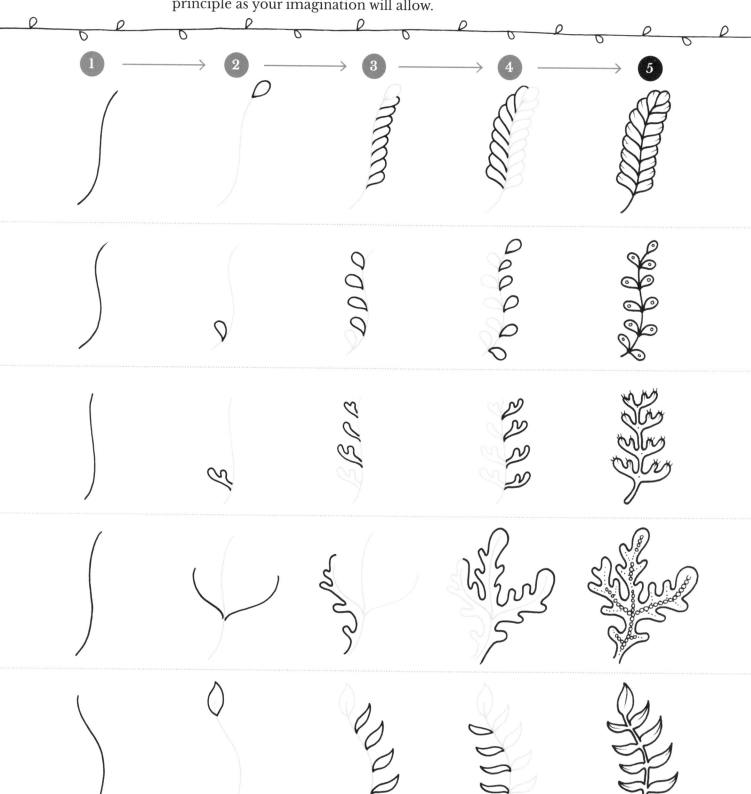

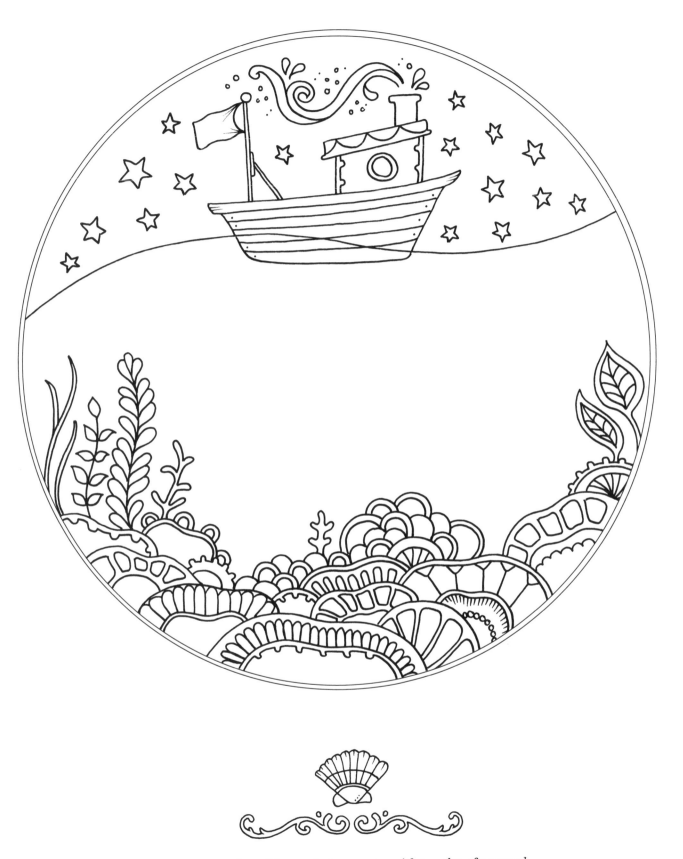

*Complete this magical seascape with tangles of seaweed,
tropical fish, and maybe a scary sea monster!*

Ship in a Bottle

I've always loved a ship in a bottle—they are so magical! Start by drawing the bottle, then add your ship, be it a pirate's galleon or a simple little fishing boat.

1

Use your pencil to draw the body of the bottle.

2

Now add the neck and a cork.

3
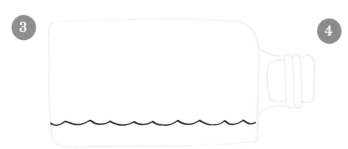

Next comes the sea.

4
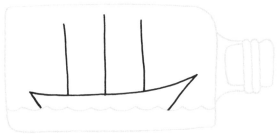

And here's our boat! Start with the hull, then add three straight lines for the masts.

5
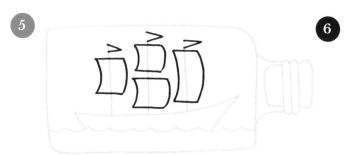

Now add some sails and flags.

6
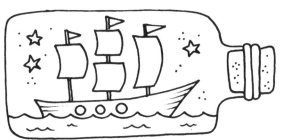

Finally, redraw in ink and erase those pencil lines. Add a scattering of stars if you'd like.

Add ships to these bottles.

Ocean Ribbon Motif

My ribbon designs all start with a single line, then I draw the artwork flowing along it. Follow the step-by-step examples below to create your own inspired ribbon. You can use this technique to create any theme of ribbon: try garden, city, or even jungle inspired!

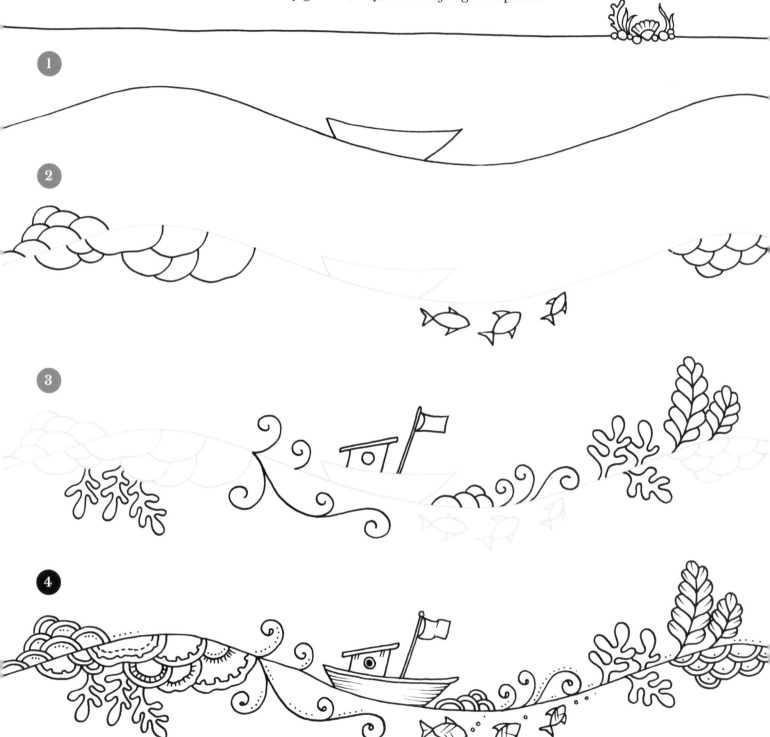

Complete these ribbons by adding your own inky details.

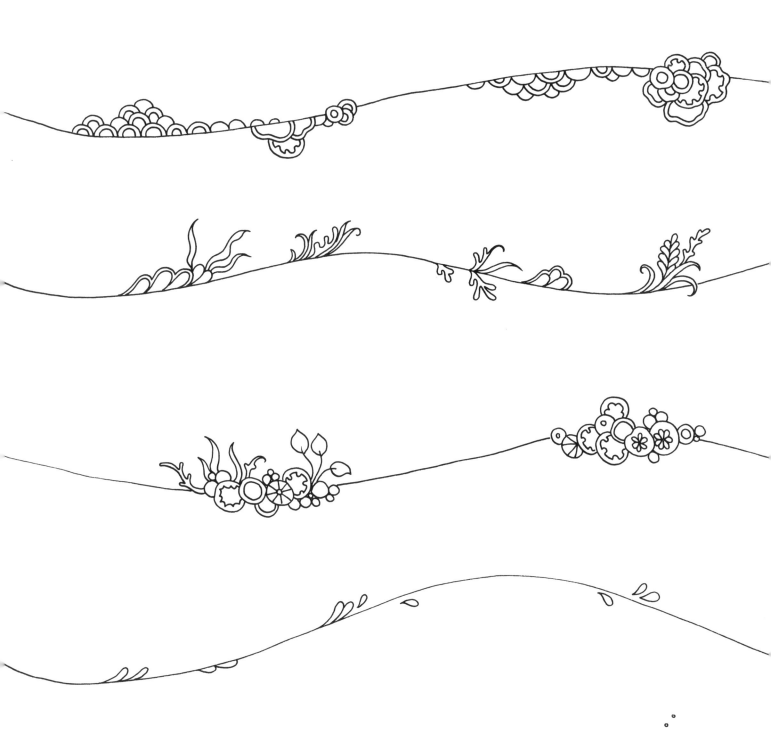

Jellyfish

Follow these simple steps to create your own unique inky jellyfish.
Add plenty of areas of surface pattern and decoration so you can
have fun when it comes to coloring!

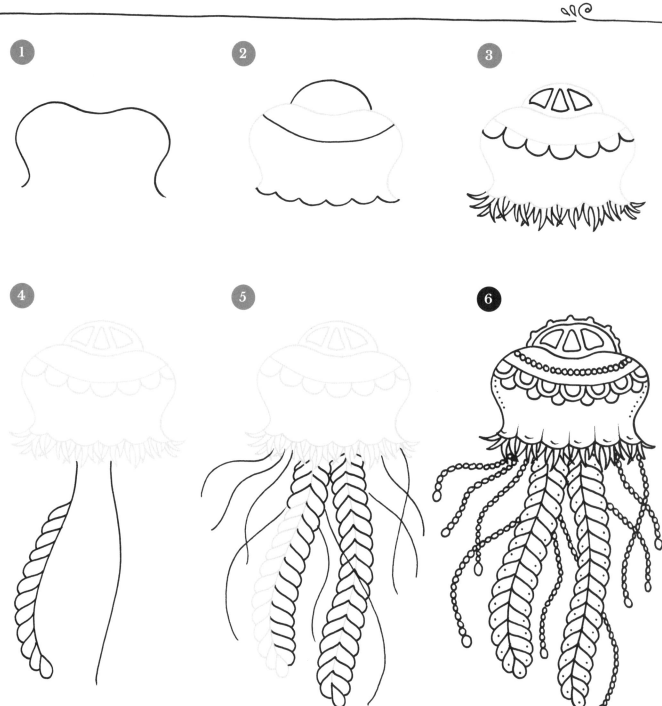

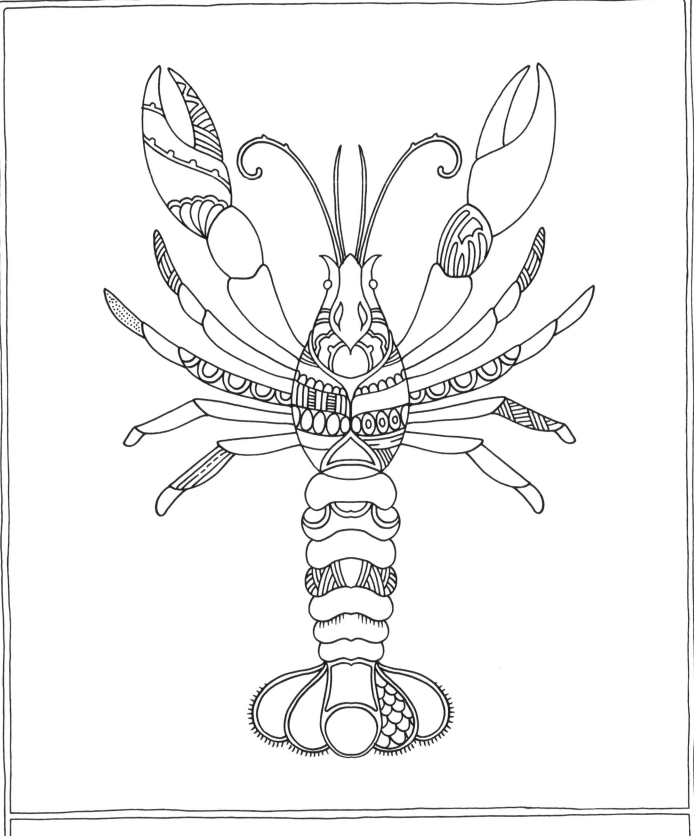

*Add patterns and colors to this little lobster
to bring him to life.*

Forest

Falling Leaves

Whether you are sketching a forest or a tiny collection of fall foliage for a border, the basic principle of leaves is always the same: Start with the stem! I like adding a few tiny dots to the curve of an oak leaf; small details like this make a drawing extra special.

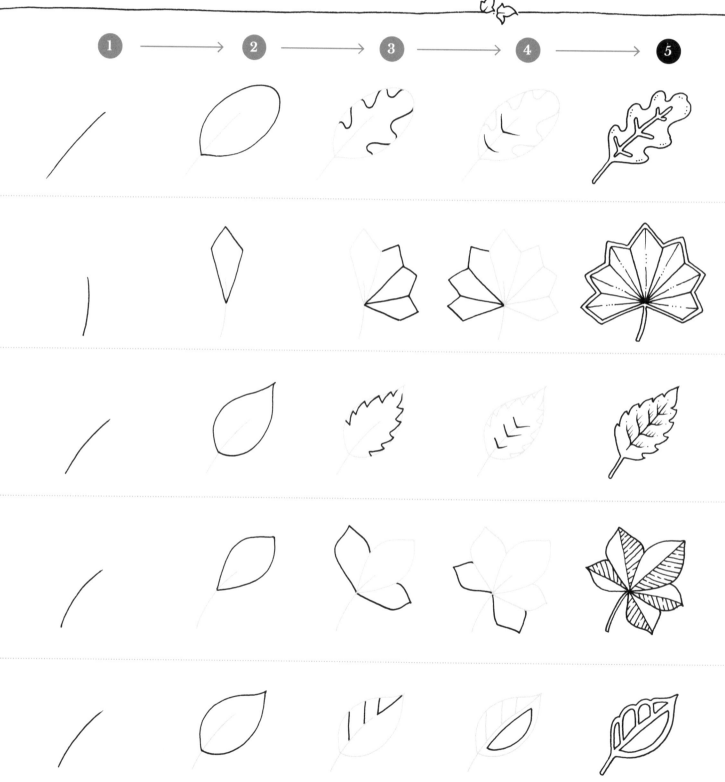

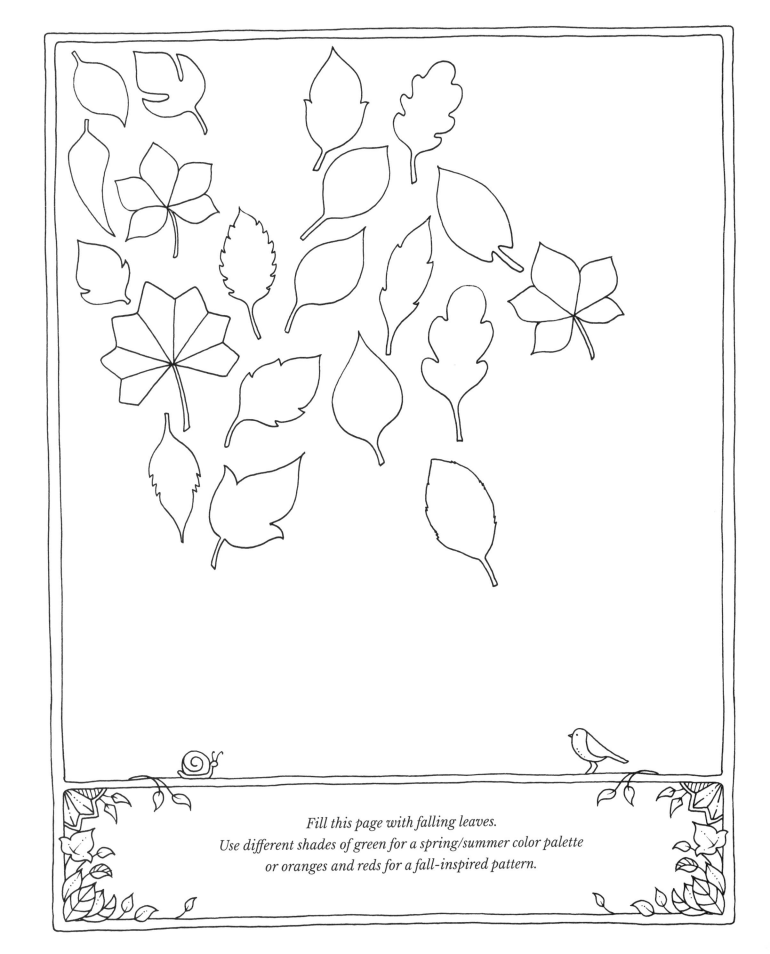

Fill this page with falling leaves.
Use different shades of green for a spring/summer color palette
or oranges and reds for a fall-inspired pattern.

Wildflower Stems

Inky details make these dainty flowers look really special, but they are super easy to draw—just a stem, a flower, and a leaf. Play with different bloom-and-leaf combinations to invent your own unique species of wildflower.

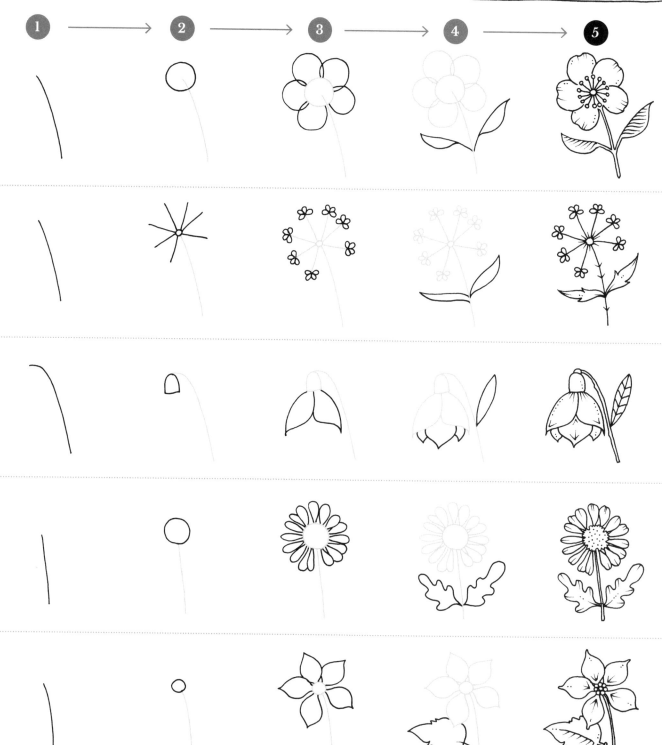

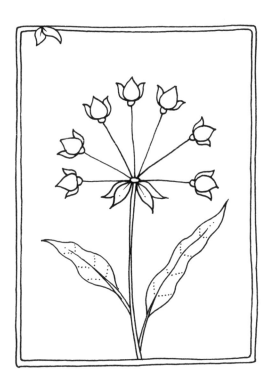

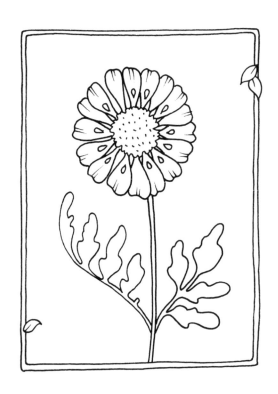

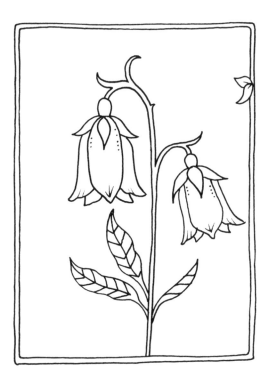

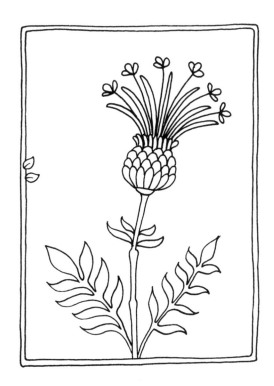

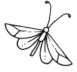

Bring these wildflowers to life with a splash of color.
Explore a garden or a botanical reference book
for some color palette inspiration.

Leafy Bugs

This technique can be applied to bugs, birds, and animals. Sketch the creature's basic outline, then fill its shape with leaves, flowers, and flourishes. A symmetrical bug or butterfly is a good place to start.

Tip: *Use metallic gel or glitter pens for the final magical touch.*

1

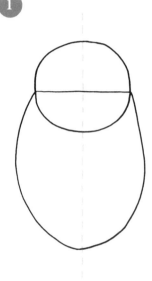

Begin with the head and body.

2

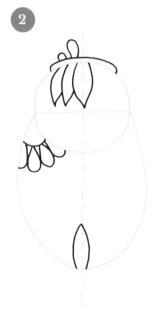

Add leafy details to one half of the bug only.

3

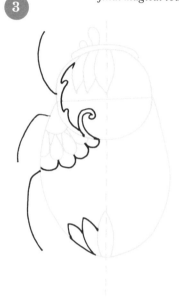

Keep adding details.

4

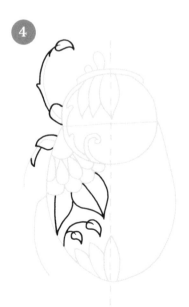

Fill the entire left side of the bug.

5

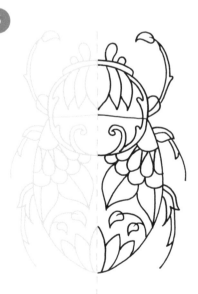

Now use your tracing paper to flip the artwork, using the symmetry trick.

6

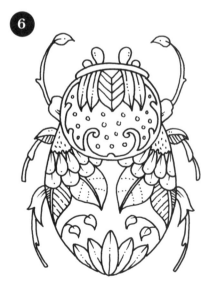

Finally, ink the sketch and erase your pencil lines.

*Add flourishes, flowers, and foliage
to the dragonfly's outline, then
add a splash of color.*

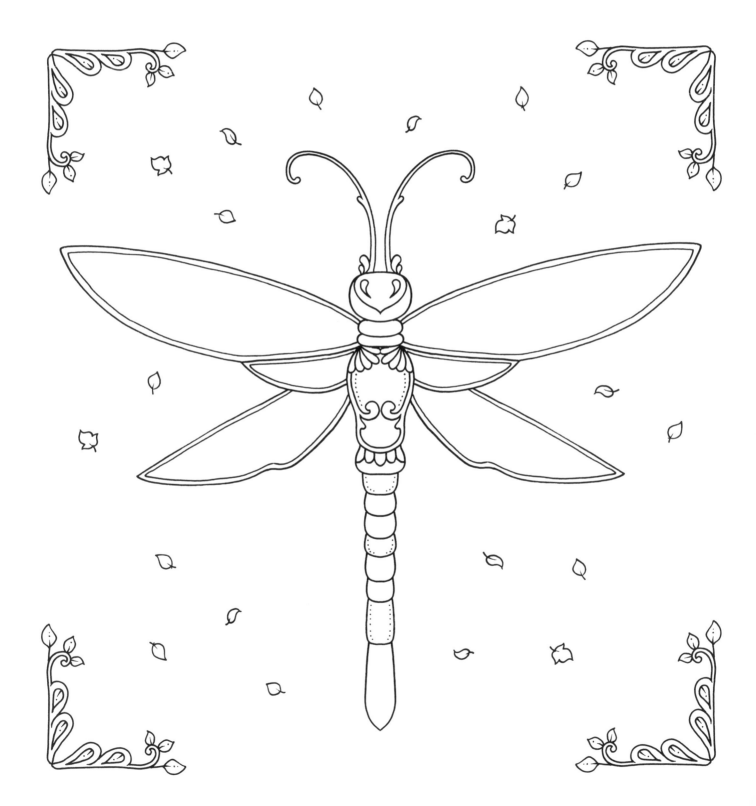

Mushrooms and Toadstools

Add clusters of mushrooms and toadstools to this enchanted forest floor.

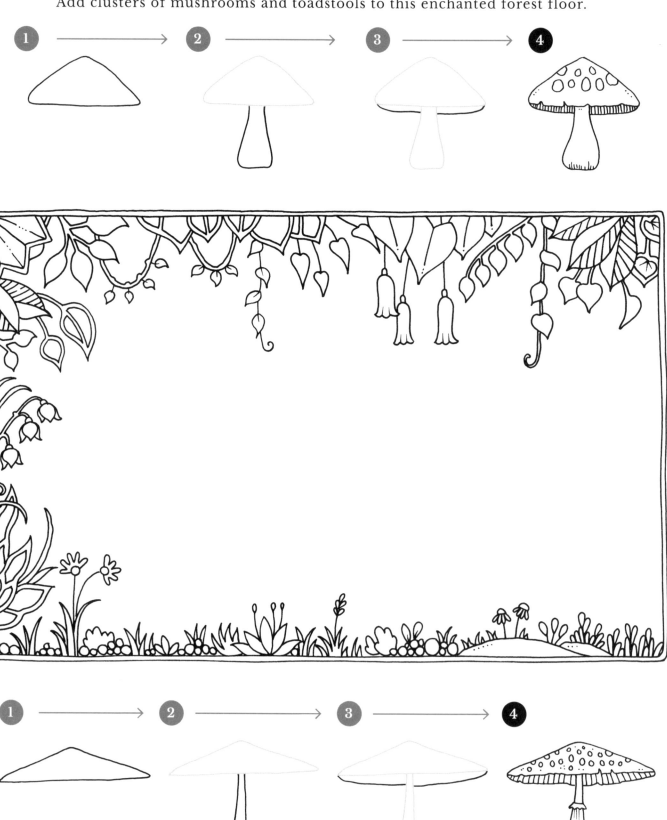

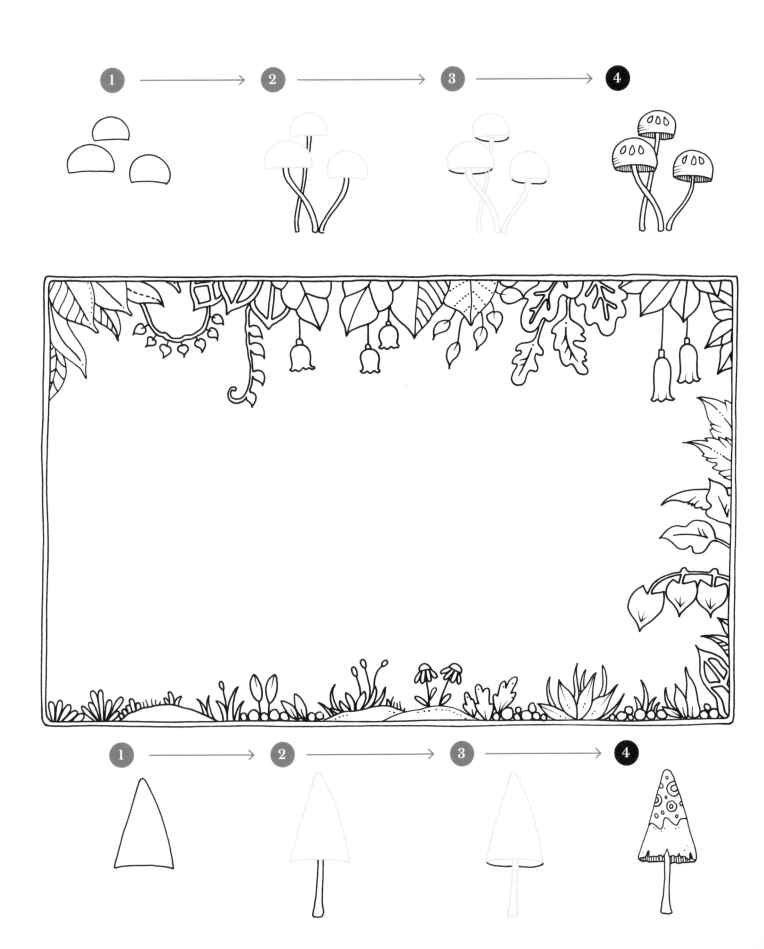

Forest Finds

From four-leaf clovers to magical lanterns, there is a wealth of treasures to be discovered in the woods. Here's a guide to drawing some of them.

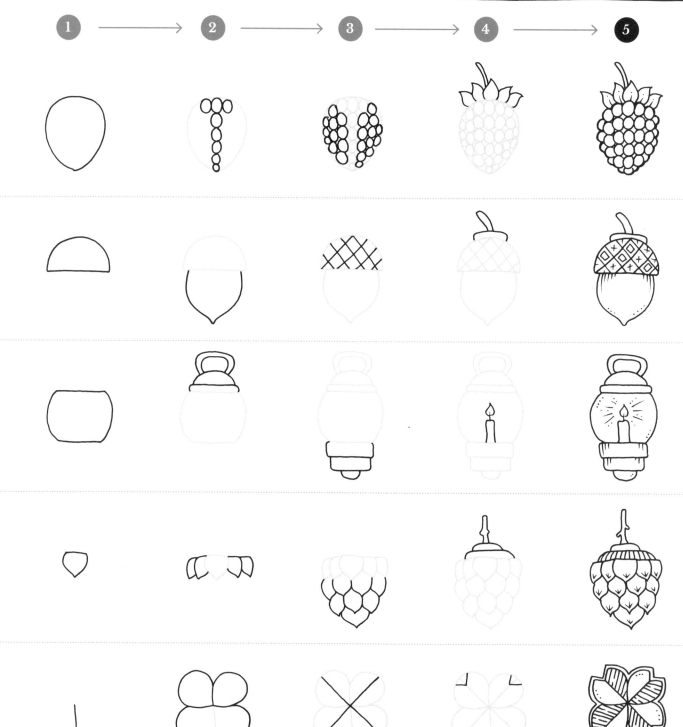

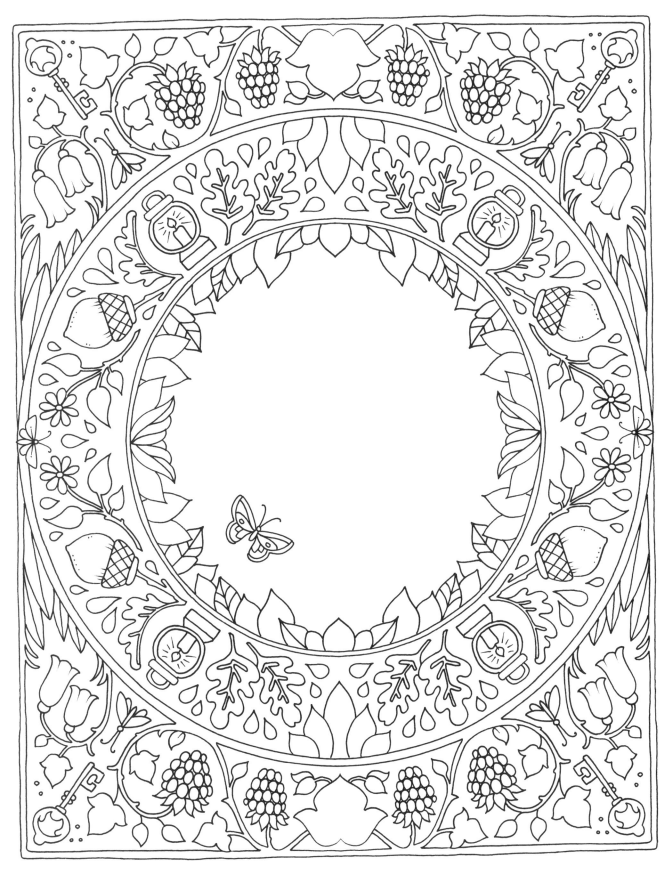

What lies at the heart of this enchanted forest design? Draw the focal point, then add color and inky details to complete the illustration.

Vines

I love to draw leafy vines climbing castle walls or creeping around tree trunks. Just begin with a stem and a single leaf, then, as you doodle, let the vine grow organically to fill the space.

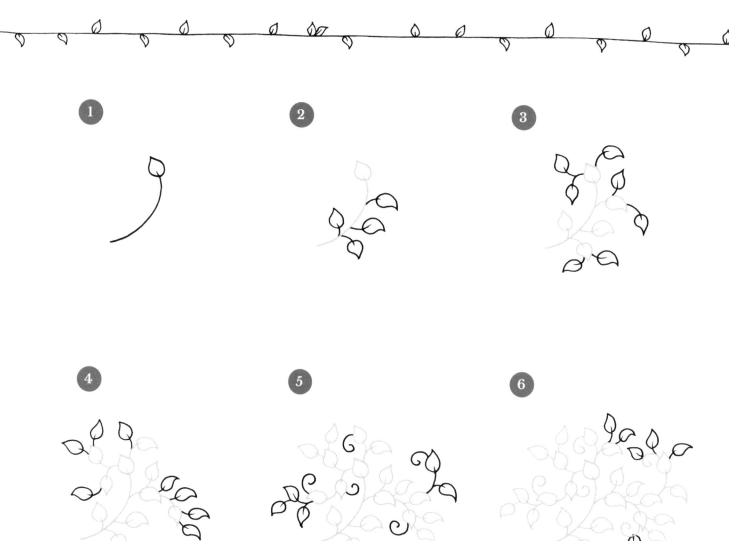

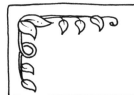

Fill this page with vines!
Try adding a few little details among the leaves—
hidden keys, a butterfly, or even a songbird.

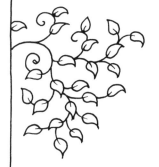

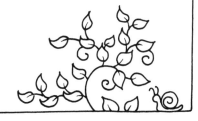

Ferns

I love the delicate little ferns that grow on the forest floor. They are so pleasing to draw—just a stem, then lots of little leaves.

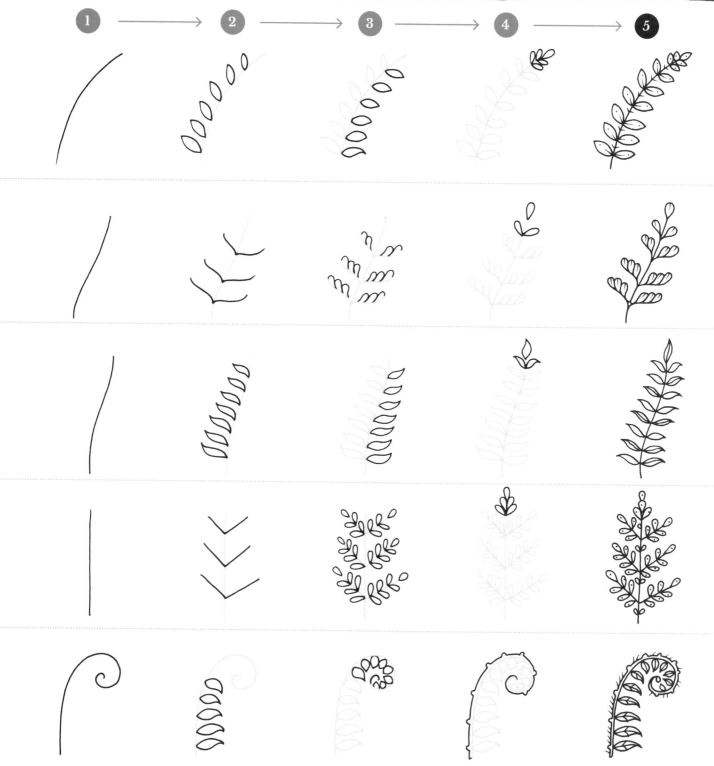

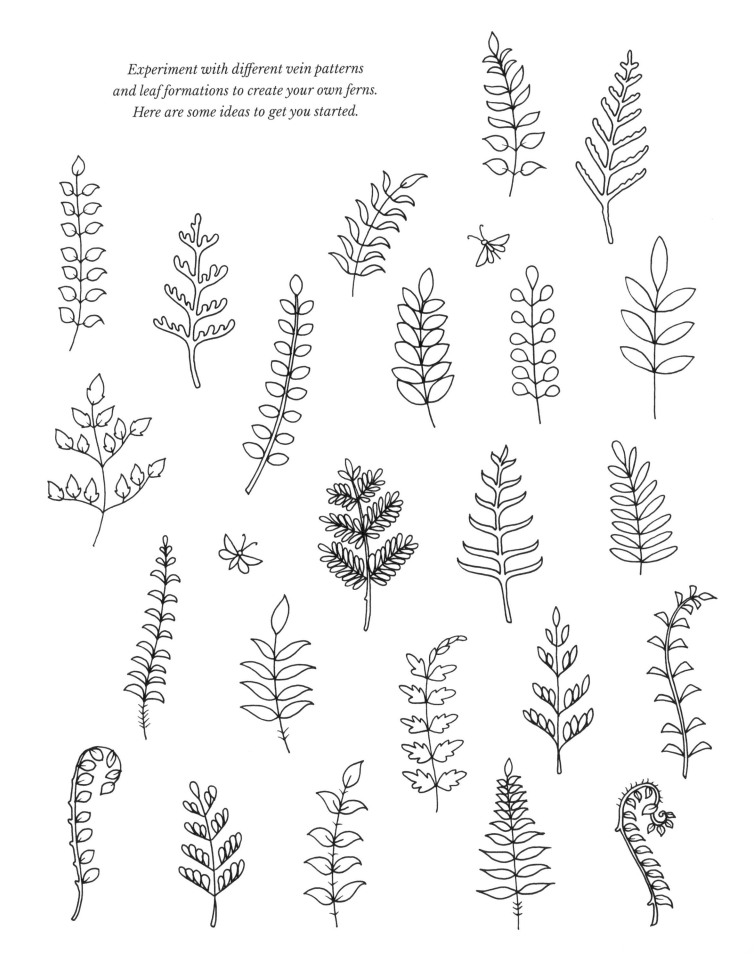

*Experiment with different vein patterns
and leaf formations to create your own ferns.
Here are some ideas to get you started.*

Borders

A pretty border or frame can transform a picture. I like to sketch mine on graph paper to help keep my lines straight. After I've completed the sketch, I trace the pattern in ink onto white paper. A square border is the easiest to start with (rectangles are a little trickier!).

Draw a large square on your graph paper, then draw a smaller square within it to create a frame.

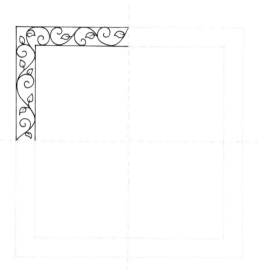

Divide the frame into quarters.
Embellish the upper left quarter of the frame.

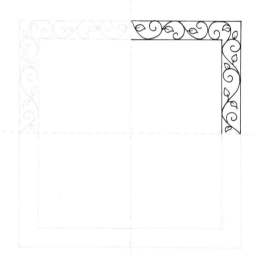

Use your tracing paper and the symmetry technique to copy the artwork to the upper right quarter.

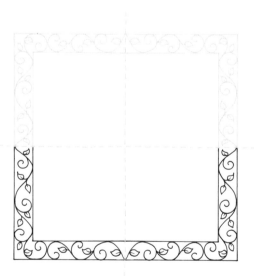

Now copy both the upper sections to the lower half of the frame to create a complete sketched border.

Finally, redraw in ink and erase the pencil lines.

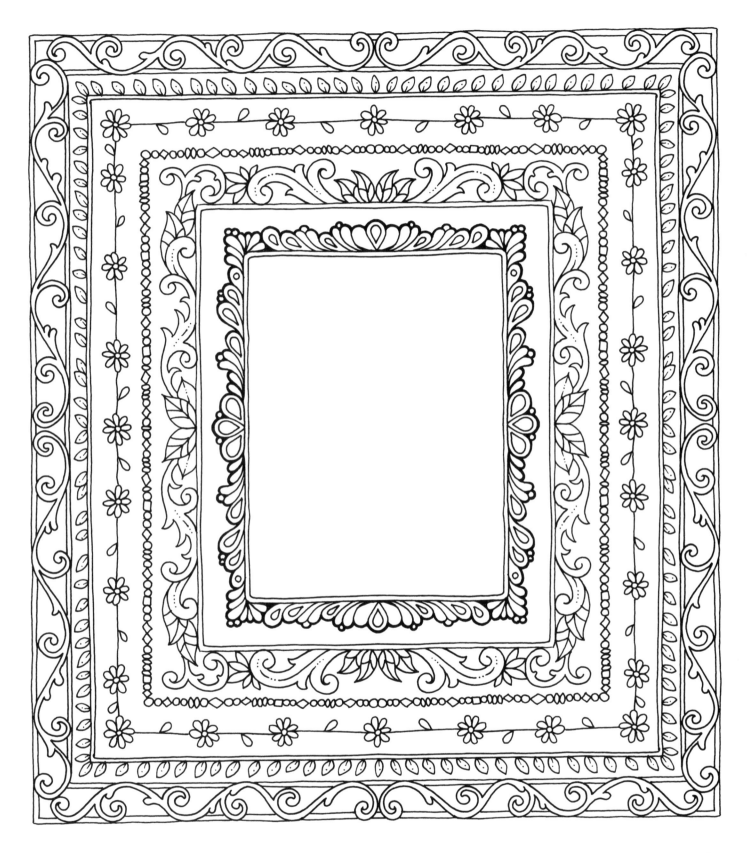

 Borders can be super decorative and full of flourishes or very simple and clean. Use these ideas as inspiration for creating your own fantastic frames.

Trees

My secret to drawing perfect trees is tracing paper! Of course trees aren't symmetrical, but I love the balance of proportions this technique creates—it feels very calming.

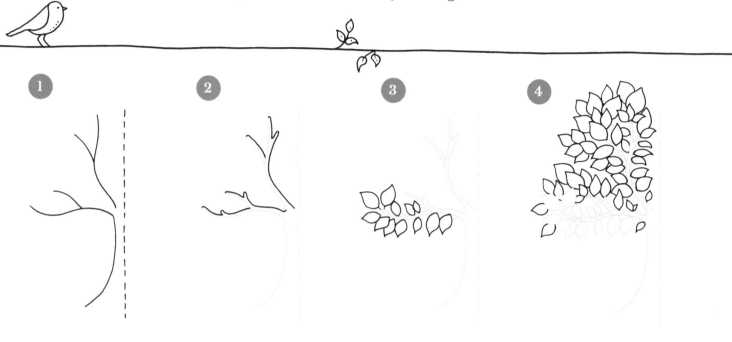

1 Begin with a vertical line of symmetry, then add a trunk and branches on one side.

2 Add a few more lines to make the branches thicker.

3 Now add leaves of different sizes and shapes.

4 Cover one side of the tree in leaves.

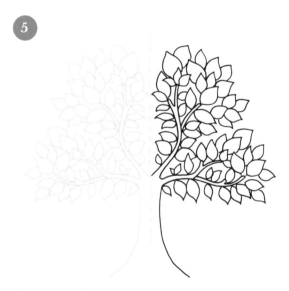

5 Use your tracing paper to copy the left side of the tree to the right side.

You will now have a complete tree, but there will be some gaps down the middle where the leaves on each side meet.

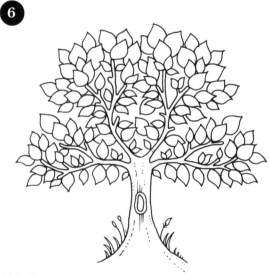

6 Add a few extra leaves to fill that central gap, then grab your pen and ink the sketch.

Add details like a squirrel's home and some tufts of grass.

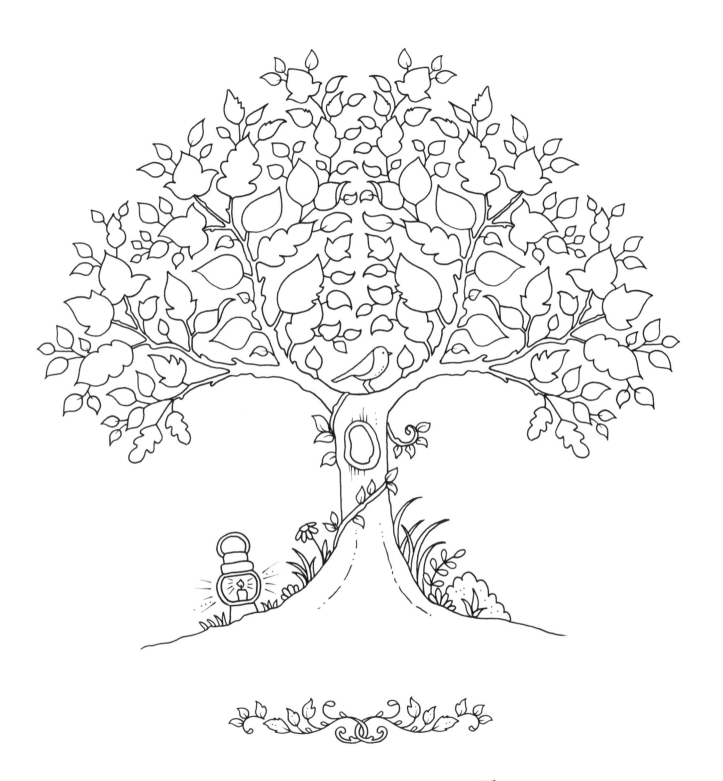

*I like to combine a lot of different leaves on one tree. When you are
drawing from your imagination, there are no rules!
What colors will you use to bring this tree to life? Remember:
Leaves don't always have to be green!*

Secret Door

No forest is complete without a magical door. Hide them on tree stumps, toadstools, or among mossy rocks. Adding little details like ivy growing around the frame and a sprinkling of stars will give your doorway an enchanted charm.

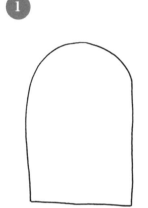

Start with a simple arch.

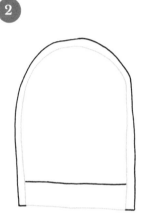

Add a doorframe and a horizontal line.

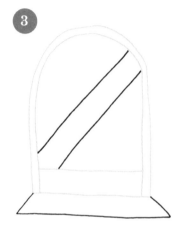

Now draw a doorstep and some diagonal lines.

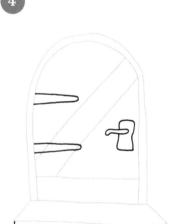

Add the handle and hinges.

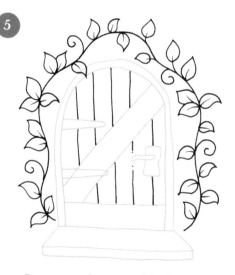

Draw some vines around the doorframe.

Having a few leaves overlap the doorway is a nice touch.

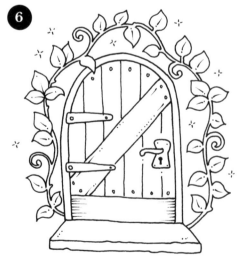

Finally, redraw in ink, adding plenty of inky details. Don't forget the keyhole!

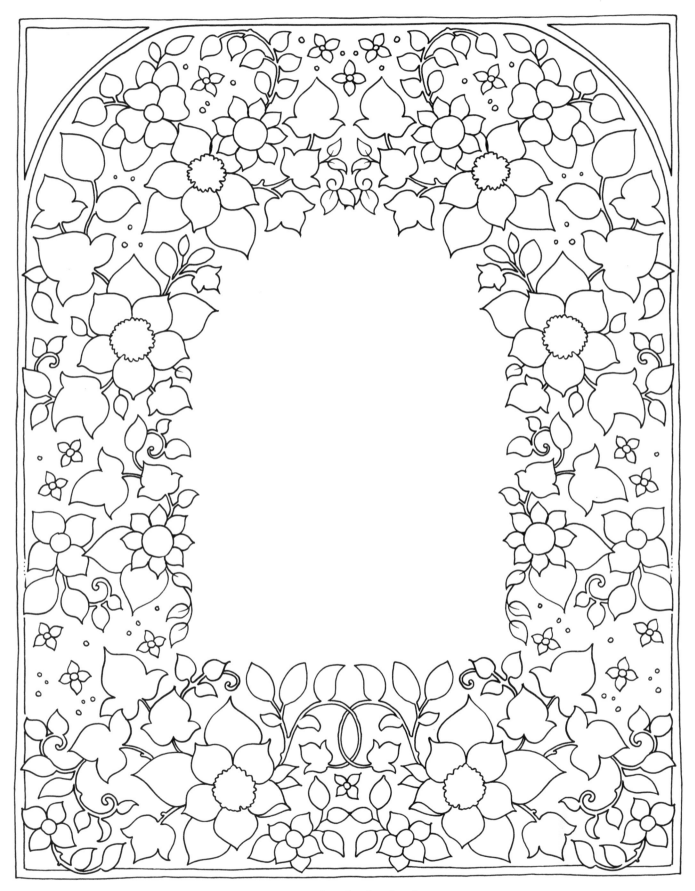

Draw a secret door in the clearing.

Owl

Owls are wonderful to draw. Begin with their big eyes, then add the body before you finish with feathers and flourishes. Adding patterns to the feathers makes them perfect for coloring because it creates areas with an abundance of small, intricate shapes.

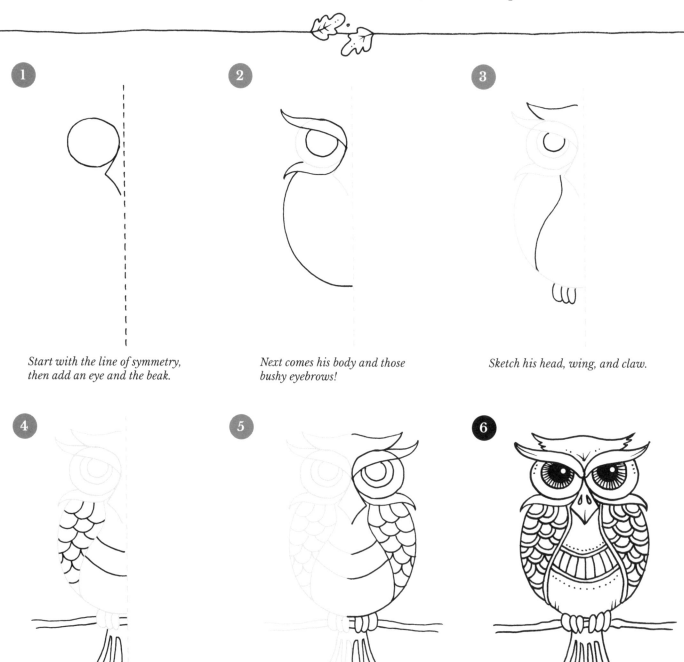

Start with the line of symmetry, then add an eye and the beak.

Next comes his body and those bushy eyebrows!

Sketch his head, wing, and claw.

Let's add a branch for him to perch on, some feathers, and a tail.

Use your tracing paper and the symmetry technique to copy the artwork, creating a whole owl.

Finally, redraw in ink, adding details and coloring his eyes black!

Frames like this are the perfect place to showcase a woodland creature.
What will you draw? An owl? A fox? A hare?
Complete the drawing, then add a splash of color.

Birds

I'll share a secret: I used to find birds *really* tricky. I worried that they didn't look like they could fly—bodies too chubby, wings too little. Then I remembered that they were *my* inky creations, so I could draw them any way I fancied!

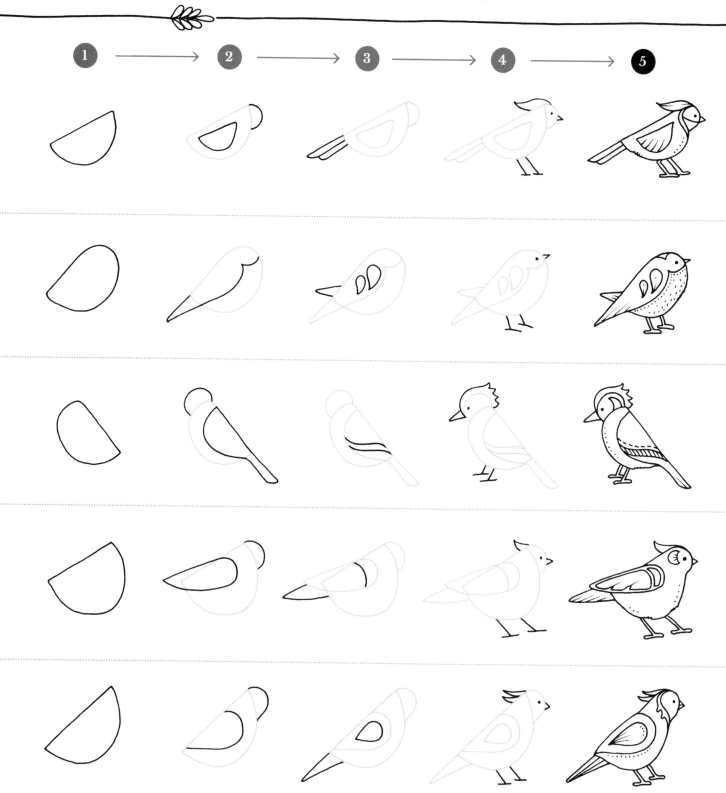

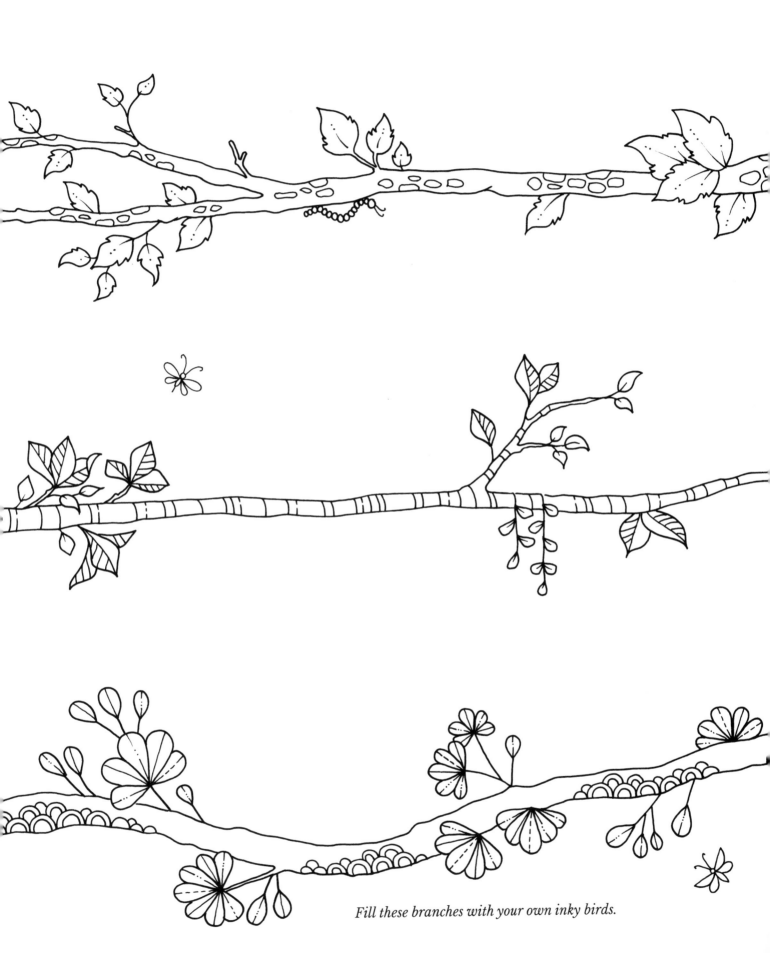

Fill these branches with your own inky birds.

Woodland Garland

I love simple little frames like this. The artwork is pretty on its own, or you can use it as a frame for lettering like your initials or business name, perfect for stationery, invitations, and logos.

1 *Begin with a vertical line of symmetry, a semicircle (I used a compass), and a small vine.*

2 *Now add some leaves in various sizes.*

3 *Add a few more leaves, some buds, and a little curly tendril.*

4 *Finish with some blossoms and a little vine.*

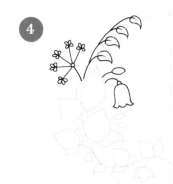

Tip: *Where the curling stems cross at the center, erase one vine on the upper crossover and the other on the lower. This creates the impression of their being intertwined.*

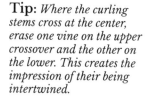

5 *Use your tracing paper to flip and copy the artwork to create a symmetrical motif.*

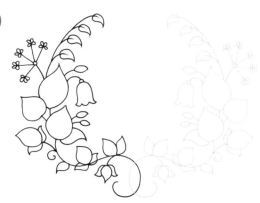

6 *Now redraw in ink and erase the pencil sketch.*

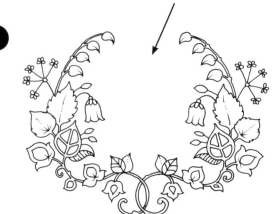